IMAGES
of America
NAPA COUNTY
WINERIES

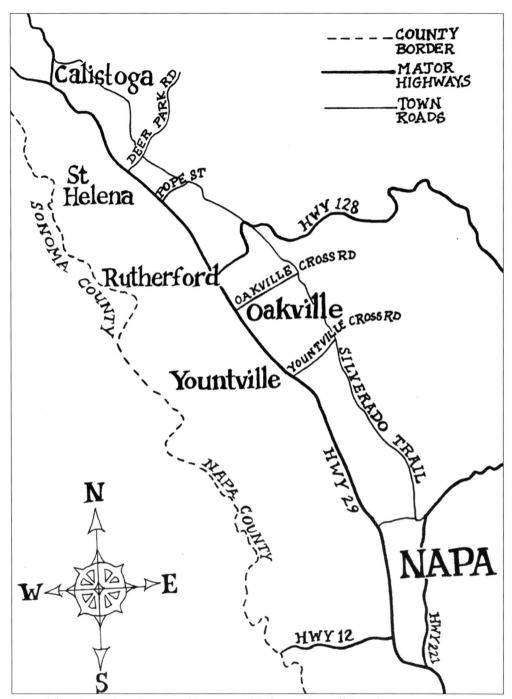

Map of the Napa Wine Country. (Courtesy of Roberta Maxwell-Long)

IMAGES of America
NAPA COUNTY WINERIES

Thomas Maxwell-Long

Copyright © 2002 by Thomas Maxwell-Long.
ISBN 0-7385-2057-8

Published by Arcadia Publishing,
an imprint of Tempus Publishing, Inc.
3047 N. Lincoln Ave., Suite 410
Chicago, IL 60657

Printed in Great Britain.

Library of Congress Catalog Card Number: 2002109591

For all general information contact Arcadia Publishing at:
Telephone 843-853-2070
Fax 843-853-0044
E-Mail sales@arcadiapublishing.com

For customer service and orders:
Toll-Free 1-888-313-2665

Visit us on the internet at http://www.arcadiapublishing.com

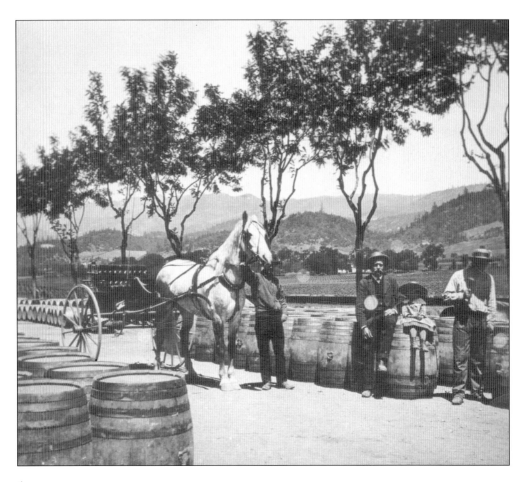

Contents

Acknowledgments 6

Introduction 7

1. 19th Century Foundations 9

2. University of California, Davis, and Viticulture 39

3. The 20th Century and Post-Prohibition Resurgence 59

4. Everybody Loves Visiting Napa Valley Wineries 103

ACKNOWLEDGMENTS

My research in the field of California winemaking history began in the spring of 1998 in my first year of graduate studies in history at California State University, Fullerton. I enrolled in Professor Gordon Bakken's graduate research seminar, which required each student to write a mid-length historical essay based upon primary research. Though my essay for that course had actually focused on the history of robbery in the state of California, I became acquainted with the process of archival research, and realized how much I enjoyed seeing a story come to life once again. Of more significance was the advice of Gordon Bakken to pursue the topics in history that we each found interesting. I have since done just that. Many thanks Gordon! Over the course of conducting my research for this project I met an outstanding wine historian, Patsy Strickland of Korbel. From the first time I met Patsy I was simply amazed at her depth of knowledge not only on winemaking and of Korbel, but also on the overall history of the region. Additionally, I have yet to encounter a better historical library and archive than Patsy's; I hope to be as organized as she is some day. Patsy, thank you for sharing your time, advice, knowledge, and sense of humor! UC Davis archivist John Skarstad was tremendously helpful in my research effort for another Napa winemaking history project, so much so that a good amount of that research has aided in this project as well. John is one of the truly good people at UC Davis that make that particular campus stand out within the University of California system; those who have conducted extensive research at UCD and at other UC campuses certainly understand. Susan Stork assisted several times, and delivered more than I asked for. On a few occasions the notice was quite short, and each case Susan accommodated my needs. Susan, your help and good nature has been very much appreciated. Giancarlo Musso's generosity in allowing me to include some of his vintage wine country photos was a tremendous help; his vast knowledge of Napa County winemaking history was always a reliable guide—both of which have helped this effort come to fruition. Special thanks goes to Luu and Bob Maxwell for the room and board that they have provided for the duration of this and other projects. Their generosity is only surpassed by their great personalities; it is always a pleasure to spend time at the Maxwell homestead. Certainly all of the wineries that have opened their archives to me and have answered my questions appear in this book and deserve my thanks. This book is dedicated to my loving wife Roberta, from whom I draw all inspiration.

All images are the property of the author unless otherwise noted. All errors and omissions are also the responsibility of the author.

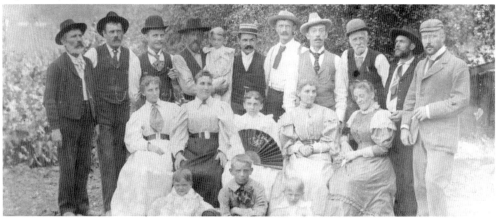

INTRODUCTION

In search of rich soil, a Mediterranean climate, and a land of breathtaking beauty, European vintners in the mid-to-late 19th century came to the Napa Valley and found the answers to their prayers. Today it seems certain that the founding families of the Napa Valley wineries had these conditions in mind when they decided to turn the valleys and steep slopes into the premier North American winemaking region, and to open up their enterprises to tourists and wine enthusiasts not just from the local area, California, or the United States, but from the entire world. They built wineries of architectural magnificence, nestled into a landscape that evokes awe from even the most stoic of visitor or resident.

Located thirty miles north of the San Francisco Bay, Napa County winemaking traces its heritage back to a time before California's entry into the Union. As the Spanish padres made their way north in the early part of the 19th century through the semi-coastal regions of California, the Napa Valley came to be their northeastern most point of discovery. The closest Spanish Mission to Napa had been located just a few miles to the west in the town of Sonoma. The Spanish and Mexican period of occupation in Napa and neighboring Sonoma County lasted but a generation before the Bear Flag Rebellion brought about political and social change throughout the coastal territory. The year 1848 briefly made California an independent republic, though all had their eyes upon statehood. The treaty of Guadalupe Hidalgo ceded California, along with other vast western landholdings to the United States, from a defeated Mexico. A tremendous gift that the Spanish Mexicans left for the Americans had been a few grapevines and the knowledge of the region's climate that was well suited for growing grapes, though winemaking was not the initial draw of the area.

With the discovery of gold at Sutter's Mill (no relation to Sutter Home Winery) in 1848, a rush for riches began that would forever transform the physical and social landscape of the Golden State. By 1850, just after one full year of serious mining from Lake Tahoe to Sacramento, the population of California was transformed. Native American tribes were decimated as the laws set in place by the European Americans robbed them of their lands and placed them in a constant state of peril. The unique nature of the California Gold Rush, at least when compared to those around the world, was that fortune seekers, eventually having enough of the miner's life for one reason or another, were compelled to remain in the land of incredible beauty and warm weather. The last few years of the Gold Rush saw the population of the state grow well beyond a few hundred thousand. Cities were built as fast as the supplies could be brought in, which included an astonishing amount of California redwood. As California was also located quite a distance from the traditional breadbasket of the United States, the need for an agricultural center within the state's boundaries began immediately.

The Central Valleys of California came to provide an adequate region for the agricultural need, and within just a few generations the Golden State became one of the leading agricultural regions in the world. Winemaking rapidly became one of the staples of this agricultural empire. By the mid-1850s Sonoma County had taken an early lead in wine production, though by the 1880s Napa had clearly overtaken its western neighbor. These early Napa winemakers discovered that folks from the San Francisco Bay Area enjoyed sojourns into the less densely-populated Napa Valley, and thus the tourist industry in the wine country began quite early on. During this initial stage of winemaking, 1870 to Prohibition, the Napa Valley wineries grew not only in number, but also in the volume of wine produced. However, for the most part the wine makers' tradition of fine wines remained intact. To be sure, "bulk wines" were still made, and

(*opposite page*) In this picture we see a large group of eager wine country tourists, *c.* 1890. (Courtesy of Korbel)

even the "best" of the wineries could not resist dabbling in the very profitable "low end" of the wine business. Perhaps it was an understanding of the significance of the identity that Napa County wines had in attracting the tourists who were willing and desirous of spending vast amounts of time and money in an area that would provide the great comforts that were in such fashion during the Victorian Age that truly saved the fine wine tradition in the valley.

By the dawn of the 20th century, Napa County had firmly established itself as the premier winemaking region outside of Europe. Many of the great wineries from this early period remain in operation today, which is no small accomplishment given that Prohibition essentially ripped away their ability to remain fiscally solvent. Today, a drive down Highway 29, which could probably be named the "Great Winemaking Highway," places the wine enthusiast in front of the finest collection of magnificent wineries and winemaking traditions that can be found anywhere in the world. Though limiting the journey to Highway 29 would be a mistake, the "second great road" lies just to the east, the Silverado Trail. These two roads are simply like no others anywhere in the winemaking world. They both run north-south through the county. The views are simply beyond description and have, in the past fifty years, come to be the homeland of not just the great centenarians of the industry, but have also given birth to a new generation of winemaking that has actually come to rival the founding fathers. This competitive yet compassionate relationship has elevated winemaking to an even higher level.

This partial list of Napa Valley wineries and their founding dates demonstrates that the process of establishing great wineries is a tradition that has stretched across many generations and one that continues into the present: Charles Krug 1861, Beringer Brothers 1876, Inglenook 1879, Christian Brothers 1882, Far Niente 1885, Freemark Abbey 1886, Beaulieu Vineyards 1900, Louis M. Martini Winery 1922, Mayacamas Vineyards 1941, Heitz Wine Cellars 1961, Robert Mondavi Winery 1966, Clos Du Val 1972, Caymus Vineyards 1972, Stag's Leap Wine Cellars 1972, Cakebread 1973, Chandon 1973, Raymond Vineyards 1974, V. Sattui Winery 1975, Duckhorn Vineyards 1976, Markham Vineyards 1978, Niebaum-Coppola Estate 1978, Cosentino 1980, Hess Collection 1982, Clos Pegase 1984, Chimney Rock 1986, Domaine Carneros 1987, Etude 1985, St. Supèry 1988. Let us hope that the tradition continues!

One
19TH CENTURY FOUNDATIONS

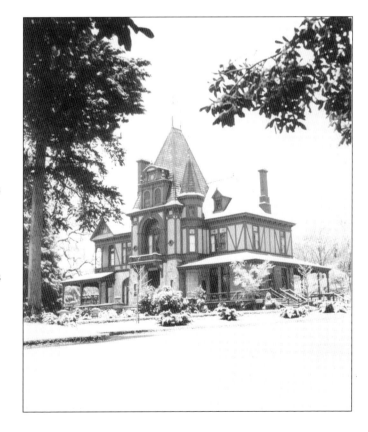

Founded in 1876 by brothers Jacob and Frederick, Beringer Vineyards became, from its earliest moments, one of the most recognizable landmarks of the Napa Valley. Over the next century the winery would survive several earthquakes and Prohibition, all the while producing a wide range of wines. Pictured here is the Beringer Rhine House in a rare snow-covered moment from a winter morning in 1890. (Courtesy of Beringer Brothers)

Pictured are the distinguished Beringer brothers, Jacob and Frederick, 1890. (Courtesy of Beringer Brothers)

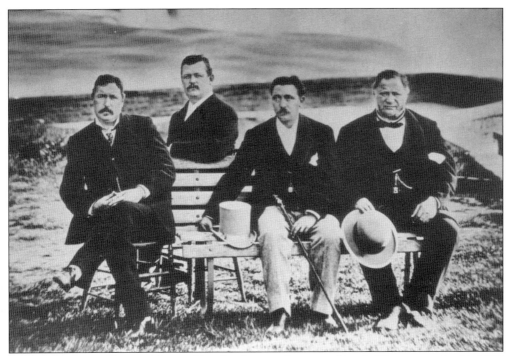

Jacob Beringer could count Grover Cleveland among his many friends. The two are in this 1879 photo; President Cleveland is seated in the rear, and Jacob is the third from the left. (Courtesy of Beringer Brothers)

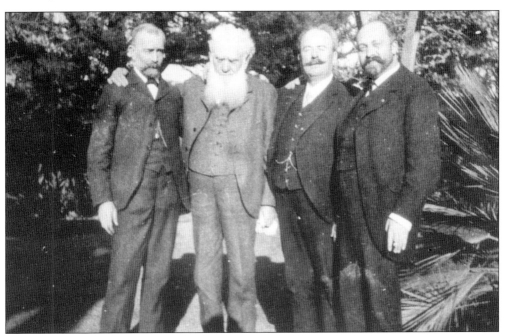

Left to right in this 1890 photo are Jacob Beringer, Jacob Schram, Mr. Grimm, and Mr. Carpy. All were friends as well as founding fathers of the Napa Valley winemaking heritage, respectively. (Courtesy of Beringer Brothers)

This view down what is now Highway 29 was taken from in front of the Beringer Vineyards looking north. The section of tree covered road with an absence of tourists is indeed a rare shot, now as it had been in 1889 when this picture was taken. Perhaps it was taken in the early morning hours before the horse and buggy wagons would cover the roads. (Courtesy of Beringer Brothers)

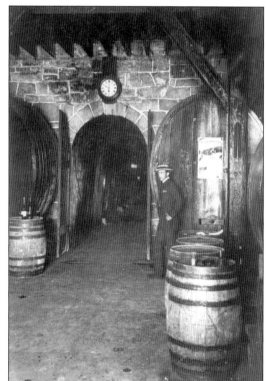

This is the interior of one of the many underground storage facilities of Beringer Vineyards, c. 1885. (Courtesy of Beringer Brothers)

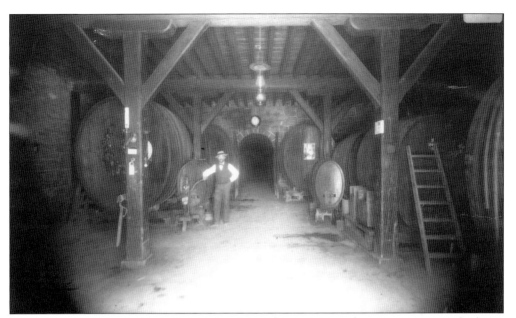

Pictured is the long, dark pathway that once was the gateway to the Beringer's aging facilities, c. 1885. Note the oil lamps at the top of the image—no electricity in the storage facilities yet. (Courtesy of Beringer Brothers)

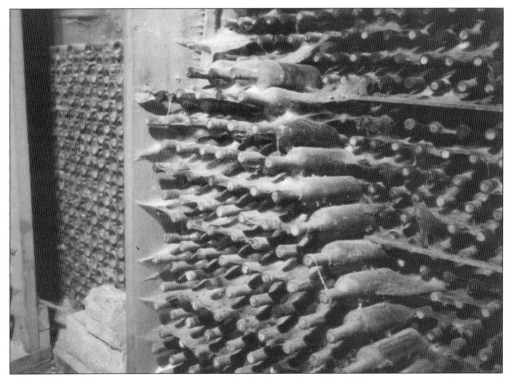

These old and forgotten vintages, many of which are from the 19th century, were discovered after Prohibition. Luckily they escaped the vengeful sledgehammers of the Elliot Ness squad. 1940. (Courtesy of Beringer Brothers)

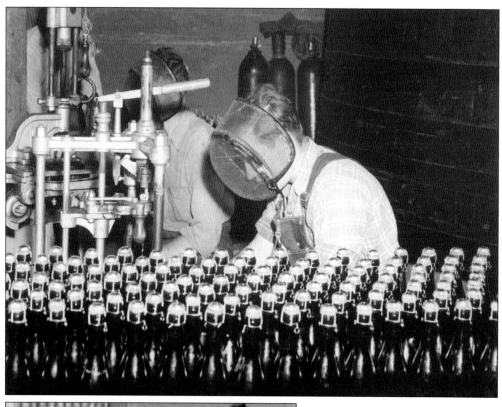

Note the heavy-duty face protection utilized here at the cork insertion station, c.1933. The two most common accidents in the bottling process were bottles exploding and corks flying. Without the proper gear an unlucky winery worker could have easily lost an eye or worse! (Courtesy of Beringer Brothers)

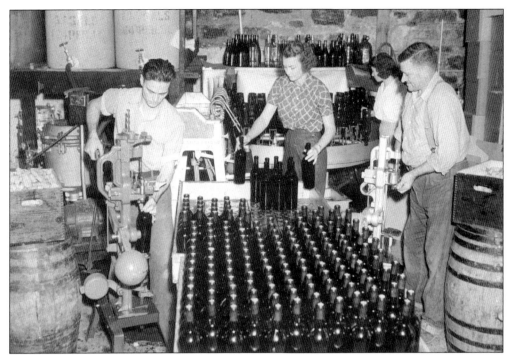

This is the first stage of "automation" in bottling at Beringer Vineyards c. 1933. (Courtesy of Beringer Brothers)

Here is the southern entrance of the Beringer storage warehouse, c. 1940. Today, as demand for Beringer wines has expanded tremendously since the early years, modern storage warehouses have replaced these earlier models, which now serve as another stop for visiting tourists adjacent to the Rhine House. (Courtesy of Beringer Brothers)

Just a few miles south of Beringer is the Sutter Home Winery. This 1879 picture of the original facility bears little resemblance to the remarkable collection of structures that make up Sutter Home today. Located in the picturesque town of St. Helena, Sutter Home is a must-stop for those visiting the Napa Valley. (Courtesy of Sutter Home)

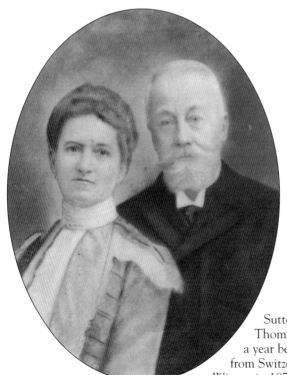

Sutter Home traces its origin back to John Thomann, pictured here with his wife in 1899, a year before his death. Thomann, an immigrant from Switzerland, opened the John Thomann Winery in 1874. (Courtesy of Sutter Home)

Sutter Home had become one of the many wineries that fell on hard times when Prohibition arrived. Though the conclusion of the dry era came in 1932, the financial stress caused by incredible reductions in revenue over the course of a decade resulted in dilapidated buildings and untended grounds. Pictured here are Mary and Mario Trinchero in New York City before departing for the Napa Valley (and this is the old Sutter Home Winery in 1939, before their arrival). (Courtesy of Sutter Home)

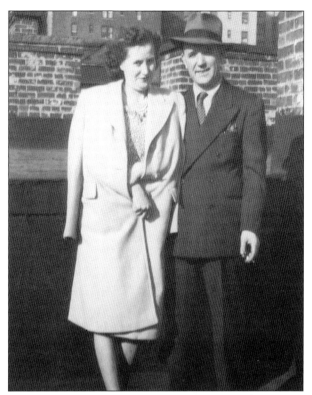

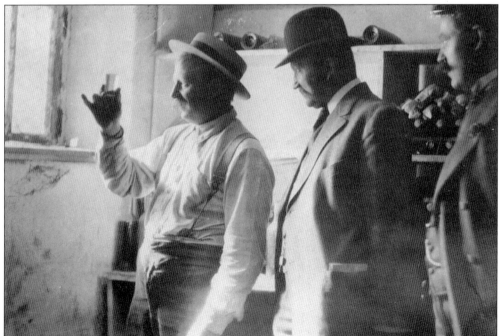

By the 1880s John Sutter moved into the Napa Valley and opened Sutter Home Winery. He is pictured here in 1887 examining a glass of his wine in the light of the sun. (Courtesy of Sutter Home)

The Trinchero family moved from New York City to St. Helena in 1947, the year of this photograph. After a few rough years of bringing back the abandoned Sutter Home winery, and getting adjusted to a lifestyle that was quite different than one might experience in Manhattan, the Trinchero's grape harvest was measured in tons, and successful harvests followed each year thereafter. This was due in no small measure to the tremendous effort and dedication put forth. (Courtesy of Sutter Home.)

At the time of this 1972 picture, Sutter Home was well on its way to being one of the most innovative and successful wineries in the Napa Valley. Roger Trinchero, the gentleman to the far right in this photo, returned to his family's winery after college and a tour in Vietnam. (Courtesy of Sutter Home.)

The changes that took place over the 100-year span at Sutter Home are quite recognizable when comparing these two images with the winery today. (Courtesy of Sutter Home)

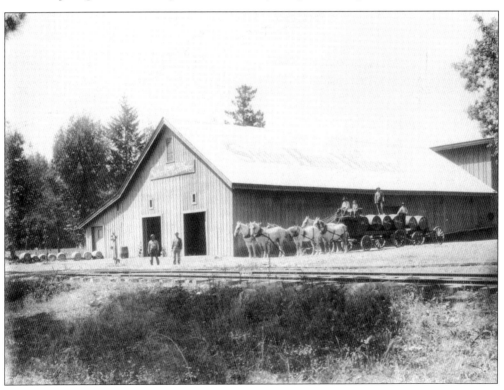

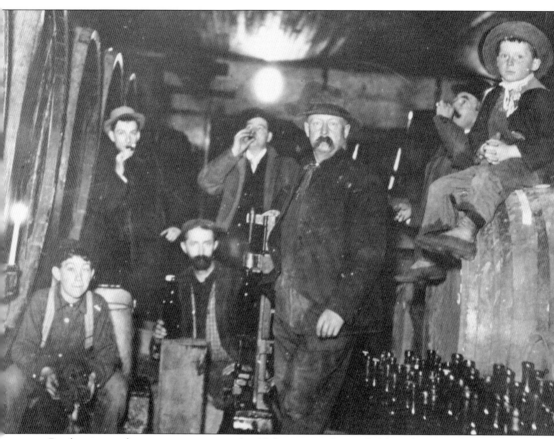

Production and storage practices in the 19th century demanded long hours and in many cases, not the most congenial working conditions. In this 1888 picture, John Sutter and his workers are posing inside of a recently filled storage tunnel for a photographer. It appears as though the workday had indeed been over as some of the men are clearly enjoying the fruits of their labor. Mr. Sutter is in the front and center of this group, with the distinguished mustache. Today many of the wineries continue to utilize caves as the storage and aging facilities for their wines. Much more cost effective than air-conditioned vaults and more environmentally friendly, caves have essentially not been replaced by the more technologically advanced forms of storage. A drive along the Silverado Trail through Napa County will reveal many of the easily seen, recently dug caves that the up and coming wineries have installed on their grounds. The mountainous sides of the valley allow the winemakers to tunnel horizontally, which is not only an easier process than a vertical dig, but also more accessible once completed. Additionally, the cavernous touch of the storage and aging facilities creates a certain mystique for the tourists that one simply does not get from a typical warehouse. (Courtesy of Sutter Home)

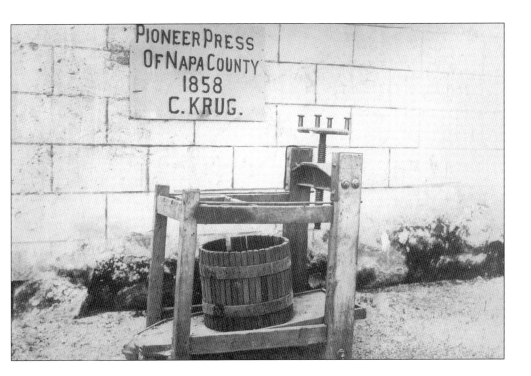

In 1861, Prussian immigrant Charles Krug founded, with his wife Caroline Bale, the Charles Krug Winery. Located between the downtown of St. Helena and Calistoga off of Highway 29, the Krug's winery is listed on the California Registry of Historical Sites, and continues to produce wine today. Mr. Krug passed on in 1892, wherein his daughters took the helm of running the winery. By the end of Prohibition the winery had become quiet, and it was not until 1943, when Cesare Mondavi, a successful winery operator from Lodi, purchased the Krug estate.

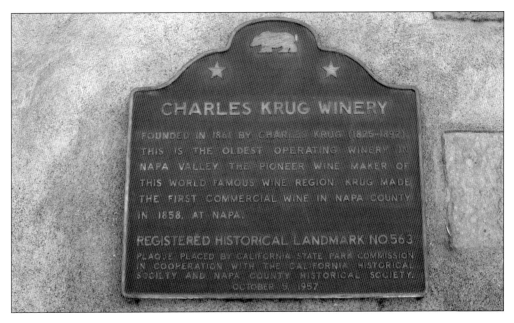

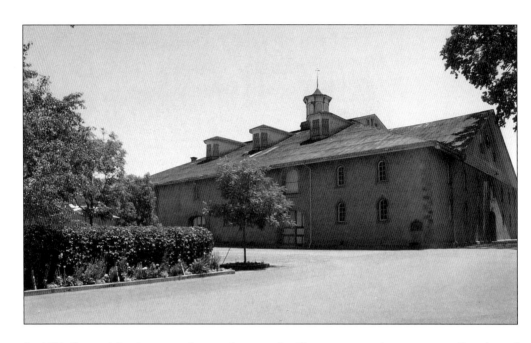

In 1959 Cesare Mondavi passed away, leaving the Krug winery to his exceptionally talented wife Rosa and their two sons, Peter and Robert. Though the two sons parted ways in 1966, the winery remained in the family, with Peter taking over the operation. Robert, of course, went on to develop his own wineries and became, arguably, the most significant person in the Napa Valley wine industry in the latter half of the 20th century. The two images are of the main central building on the Krug estate, which remain fully intact and are in the same working shape now as they had been over a century ago.

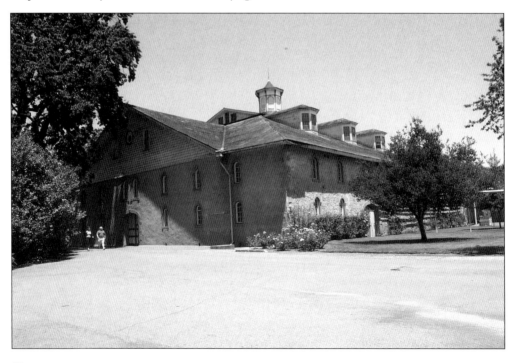

Pictured here is the main building of Greystone winery c.1885, along with a recent photo. Perhaps no other building in the Napa Valley stands out as does Greystone. Today Greystone is no longer the great winery that it once was; however, it is now home to the Culinary Institute of America. One of the most visited stops along Highway 29 through the Napa Valley, this world-renowned culinary institute also features a fine dining restaurant and is a must-visit for anyone visiting the wine country. (Courtesy of Korbel)

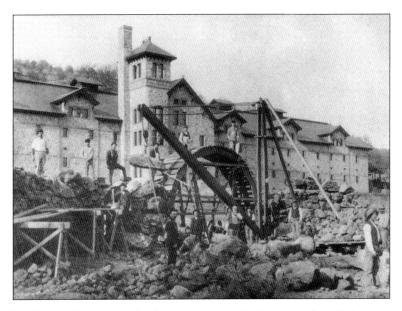

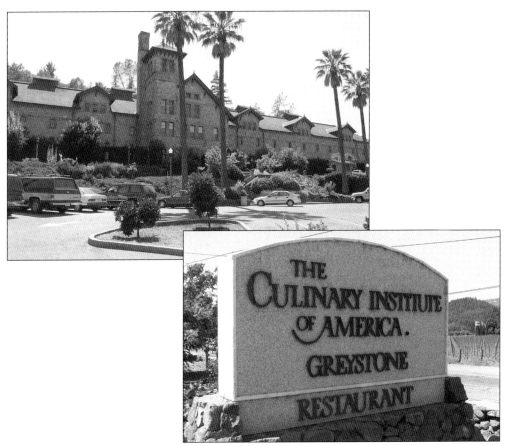

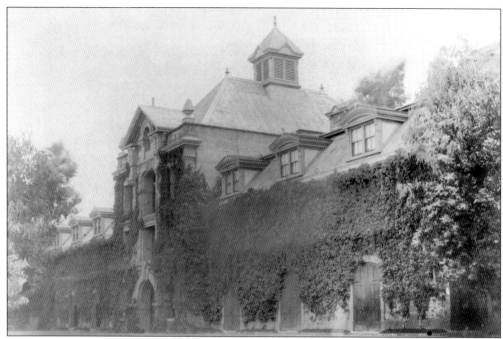

The original Inglenook gothic revival main house represents the 19th century's Gilded Age as well as any, c. 1890. Built by the founder of Inglenook, Gustave Niebaum, this opulent edifice continues to draw thousands of tourists each month, and is currently the main house for the Niebaum-Coppola Estate winery. (Courtesy of Korbel.)

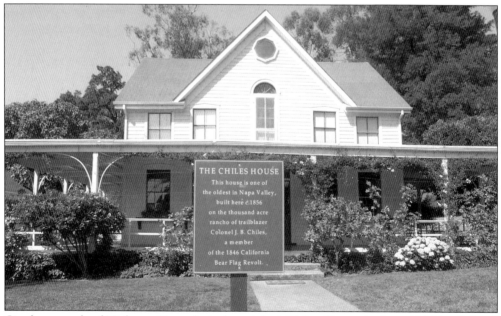

On the grounds of Niebaum-Coppola is the original Chiles House, built in 1856 by Colonel Chiles, one of the original members of the Bear Flag Revolt. This well-kept, modest farmhouse, typical of the well-to-do families of the early California period, is nearly out of place alongside the magnificent structures that make up the central area of Niebaum-Coppola.

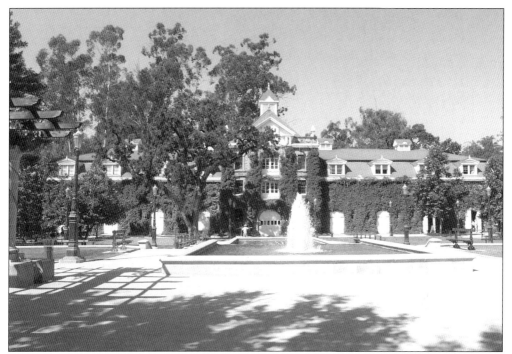

In 1978, movie director Francis Ford Coppola purchased the former Inglenook Niebaum winery, renaming it Niebaum-Coppola. The full restoration process took several years, and upon its completion the winery became one of the top draws in the Napa Valley.

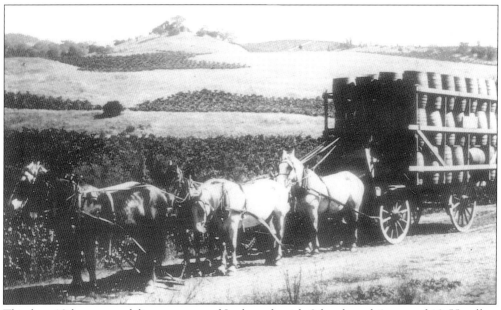

This late 19th-century delivery wagon of Inglenook with 3 levels and 4 rows of 10 55-gallon barrels testifies to their success in the winemaking business quite early on. Though when compared to the level of production today at the Niebaum-Coppola winery, this would represent but a fraction of the total output. (Courtesy of Giancarlo Musso)

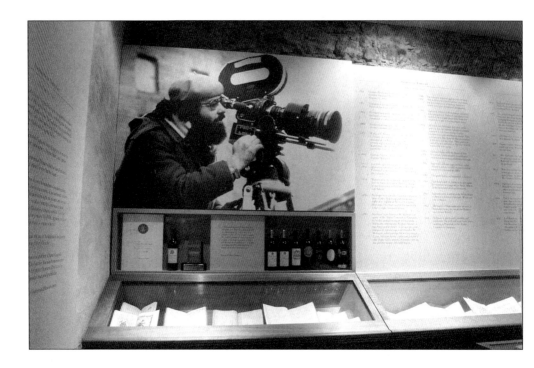

The first floor of the main house serves as the tasting room for the winery, with vintages from each generation of winemaking throughout the 20th century. The second floor serves as the depository for many of Mr. Coppola's movie-related memorabilia, including his Oscar trophies, which are on display for the public.

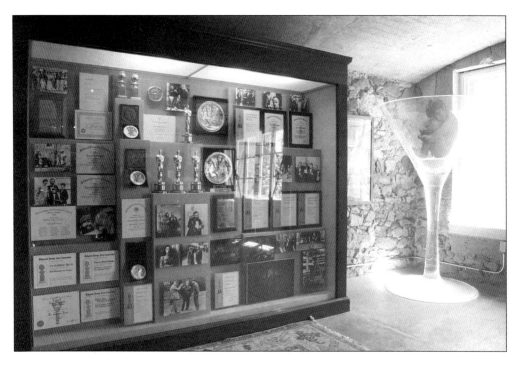

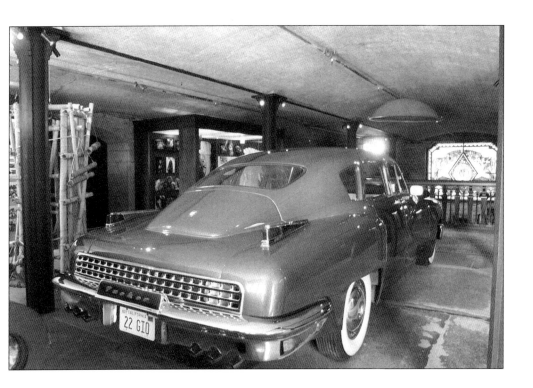

Fans of Francis Ford Coppola will also recognize the costumes from his adaptation of Dracula, though what truly stands out is his rare Tucker automobile, located in the center of the film exhibit on the second floor. The real mystery here is how Mr. Coppola was able to situate the automobile in its present location.

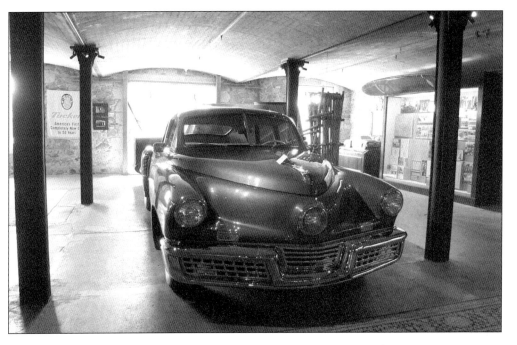

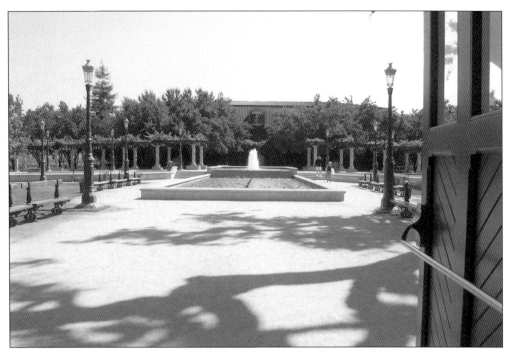

The view from the main entrance of the house across the plaza reveals one of the magnificent fountains and to its rear is the storage facility, which in its own right is a piece of architectural art. The late 19th-century design that can been seen at many wineries throughout the valley is not represented any better than at Niebaum-Coppola.

The Schram Mansion, c. 1885, truly represented the immense success that Mr. Schram's Schramsberg Vineyards held in the 19th and 20th centuries. Founded in 1862, Schramsberg Vineyards sat idle for nearly a half-century following Prohibition. In 1965, Jack and Jamie Davies purchased the dormant winery, complete with aging caves, and within a few years were producing over 25,000 cases of wine. (Courtesy of Christian Brothers)

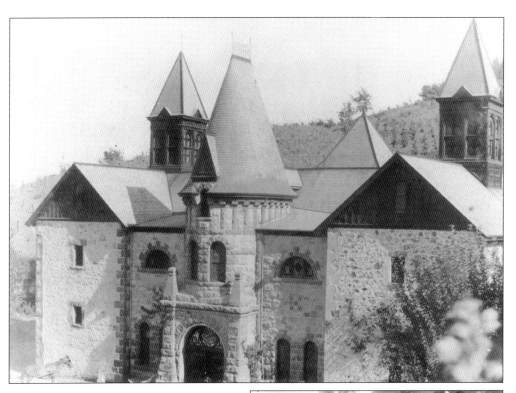

As the success of the Napa Valley winemakers continued to rise during the last 20 years of the 19th century, the once completely rural landscape witnessed not only vineyards occupying the former grassy hills, but also many a European-styled chateau. Korbel general manager Frank Hasek photographed this particular chateau, Chevalier Chateau, in 1896. (Courtesy of Korbel)

Frank Hasek, an immigrant from the Czech Republic in the latter part of the 19th century, was the general manager of Korbel Enterprises for nearly two generations. Pictured here, c. 1890, in his Sunday best, Mr. Hasek was also an avid photographer, and master of the glass-plate technique. Though only a hobby for the serious businessman, his photographic work now compiles one of the finest records available for both the Napa and Sonoma County wineries. Many of the vintage images in this book are the work of the talented Mr. Hasek. (Courtesy of Korbel)

In this c. 1890 Frank Hasek photo is his lovely wife Karla Fortova-Hasek. Mrs. Hasek is the lady furthest to the left. (Courtesy of Korbel.)

It is easy to tell if your husband is obsessed with taking photographs when he records your mother's death, as did Frank Hasek in this 1895 photograph of Katerina Fort, short for Fortova. Noted Korbel historian Patsy Strickland has aptly and humorously titled this rare piece of macabre the "dead lady picture." (Courtesy of Korbel.)

In this Hasek photo are some returning veterans of the Spanish-American War along with Anton Korbel. Though nearly forgotten in popular American memory, the Spanish-American War ushered the U.S. not only into the 20th century, but also through its victory in Cuba and the Philippines. (Courtesy of Korbel)

Many will recognize this Napa County icon, the Pioneer Water Mill in St. Helena. Frank Hasek took this photo in 1896 during one of his many trips through the Napa Valley. (Courtesy of Korbel)

Hasek recorded all stages of the building process of the wineries when he could. These 1890 images recorded the process of clear-cutting that was necessary for the planting of the vineyards in many of the choice locations throughout the Napa and Sonoma Valleys. Today such massage re-shaping of the earth would probably meet with great opposition from environmentalists; however, if these founding families had not acted with such aggression, the entire Napa-Sonoma region would not contain nearly as many vineyards and their collective economies would probably not be agriculturally based. (Courtesy of Korbel)

Though the initial stages of the clear-cut method not only produced a view that was less than appealing, the harsh impact upon the environment was felt immediately. Some of the unforeseen adverse affects would include ground water and soil contamination from the overuse of dynamite in the removal of the large oak and redwood tree stumps as captured here in this remarkable Hasek photo. Soil erosion also complicated matters as many of the streams and rivers would fill with the silt that would wash down from the then barren hillsides. As has usually been the case in history, man learned from his mistakes the hard way. Clear-cutting would come to be banned in the two wine producing counties by the close of the 19th century. (Courtesy of Korbel)

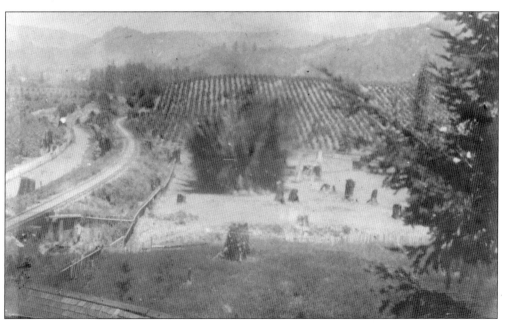

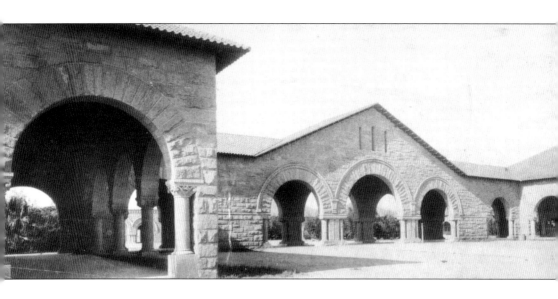

The great industrialists of Northern California that rose to great levels of wealth beginning with the California Gold Rush may have been a bit shortsighted in the manner in which they generated their incredible wealth. Aspects of their legacy today that are quite positive and which certainly serve the people not only of California, but also the U.S. and the rest of world include the formation and funding of two of today's finest universities, Stanford and the University of California. These Hasek photos were taken at the opening-day festivities at Leland Stanford Jr. University in the 19th century. The Stanford campus looks quite different today, with a hundred more buildings and countless trees. Recent alumni might have difficulty recognizing the locals depicted in these images. (Courtesy of Korbel.)

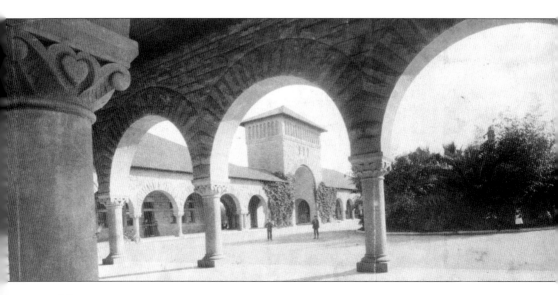

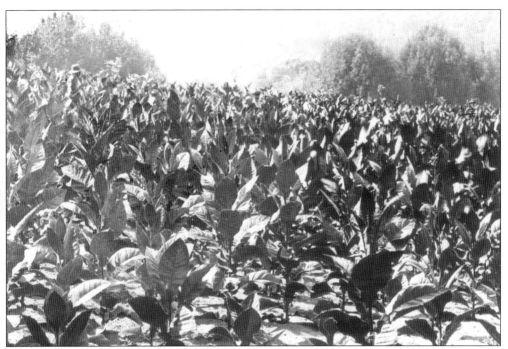

Much to the surprise of many people today, another crop that made a brief appearance in the Northern California wine country in the late 19th century was tobacco. This 1890 Frank Hasek photo probably captures one of the best crops ever raised in the wine country, as the climate is simply not conducive to successful tobacco plantations. (Courtesy of Korbel)

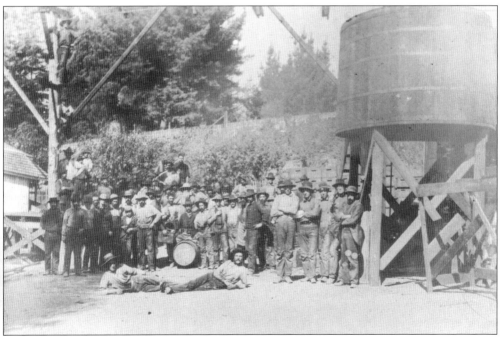

These hardworking men appear to be enjoying a brief rest from work as they pose for Mr. Hasek's camera, *c.* 1890. (Courtesy of Korbel)

Today Korbel is probably the most recognized name in American champagne. At the start of the 20th century there were several others in that field. Hommels, pictured here in 1900, had been one of the early California champagne makers. (Courtesy of Korbel.)

Pictured here are the Hommel champagne vineyards on what appears to have been a crisp spring morning, c. 1900. (Courtesy of Korbel.)

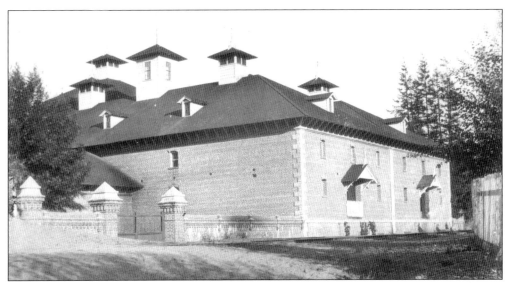

Mere mention of Korbel is simply not enough. Though located in Sonoma County, Korbel Champagne Cellars has had an incredible effect on the entire California winemaking industry since its founding in 1882. Situated along the magnificently picturesque Russian River, Korbel has, over the past 120 years, consistently raised the bar of excellence for the Napa and Sonoma winemakers. With a fine line of wines that go beyond their legendary trademark champagnes (Korbel is the official champagne of the White House), wine lovers have for many generations sought out the trusted Korbel label. This Hasek photo records the completion of the central building in 1895. (Courtesy of Korbel)

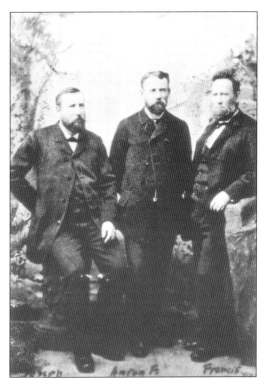

Pictured here c. 1882 are Joseph, Anton, and Francis Korbel, immigrants from the Czech Republic as was Frank Hasek. (Courtesy of Korbel)

The Korbel family house is still standing today at Korbel Champagne Cellars, and thanks to the meticulous upkeep that current owner Gary Heck has insisted upon, this 1895 Hasek photograph could pass for a contemporary image. (Courtesy of Korbel)

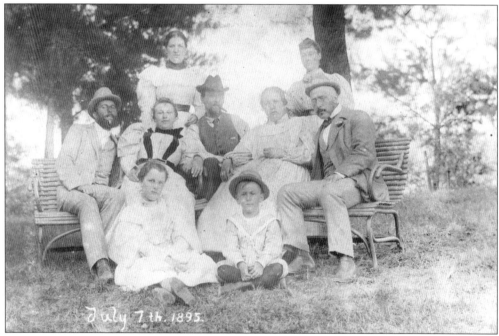

In this July 1895 picture are some of the Korbel family members, with Caroline Korbel to the left in the back row. Caroline would become one of the first female big business presidents in the early part of the 20th century and would also guide the family business through the rough waters of Prohibition. (Courtesy of Korbel)

Two
UNIVERSITY OF CALIFORNIA, DAVIS, AND VITICULTURE

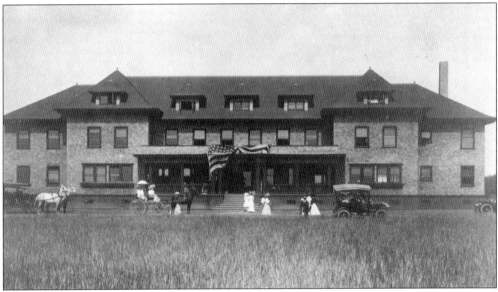

At the dawn of the 20th century the great University of California built two agricultural research stations: Southern California's Citrus Experiment Station appeared in Riverside, 60 miles east of Los Angeles, and Northern California's Agricultural School appeared in Davis, 20 miles west of Sacramento, 60 miles east of San Francisco, but even more importantly, just a bit over 30 miles east of the Napa Valley. University of California had made a name for itself within the first decade after being founded in 1868; by 1900 it was one of the most respected research institutions in the world. Within a few years of the opening of the School of Agriculture, serious attention was being given to viticulture, a thriving component of the California agricultural economy. The proximity of Davis in regards to the Napa and Sonoma Valleys, as well as the Sacramento and Central Valleys, gave the professors and students the opportunity to conduct their viticulture research in conjunction with the growers and winemakers. Thus a profitable and symbiotic relationship emerged, which continues to this very day. This image records the first picnic day in front of the administration hall at the University of California, Davis during the first decade of the 20th century. (Courtesy of UC Davis Shields Library Archival Collections)

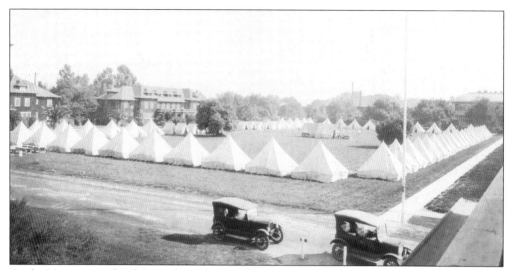

As the University of California began to develop its agricultural campus in Davis, it continued to adhere to one of the tenets of its foundation, which is to serve the populace of the State of California. In this c.1908 picture the students of the agricultural school are doing just that. This tent city was part of the University's early outreach program that was geared to reaching high school-age students that were members of such youth organizations as Future Farmers of America, members of the local Grange, and the 4-H clubs. It was through programs such as this that the teenagers were given a taste of "real" college life. (Courtesy of UC Davis Shields Library Archival Collections.)

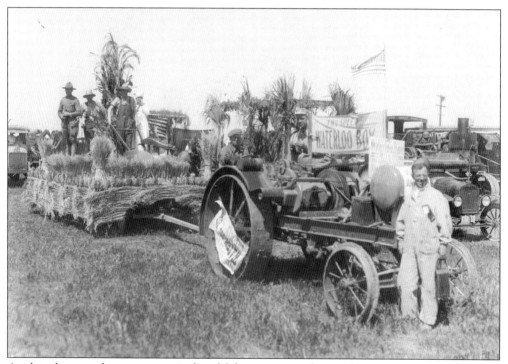

As this photograph suggests, agricultural life is not complete without a genuine tracker ride. (Courtesy of UC Davis Shields Library Archival Collections.)

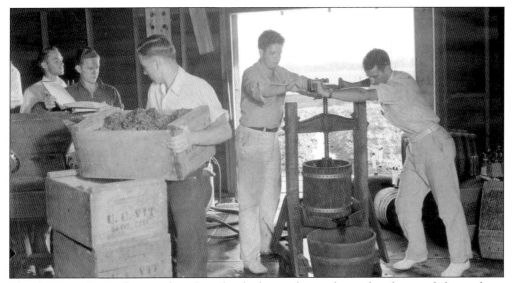

The division of viticulture within the school of agriculture educated and trained the students in both the scientific fields of botany and plant management, as well as the practical applications of producing wine, from the planting of vineyards through the harvest, crush, and fermentation processes. The students in this picture are loading and crushing the grapes, and it appears as though they are dressed in a more suitable fashion for picture-taking than working with grapes—not many vineyard workers wore white slacks and loafers and dress shirts while performing the same tasks as seen in this c. 1910 picture. (Courtesy of UC Davis Shields Library Archival Collections)

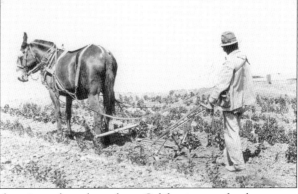

Proper cultivation of the soil is an essential aspect of crop maintenance, and viticulture is no exception to the rule. This 1923 UC instructional card demonstrates the correct method of cultivating with one horse. Though the internal combustion engine along with the tractor had been in production in the U.S. for nearly 10 years when this picture was taken, it remained an expensive piece of machinery that was well beyond the means of most farmers. As the winemakers throughout California were for the most part decimated by Prohibition, they comprised the poorest sector of the agricultural economy of the state. The University of California recognized their economic woes, which led to their instruction on the usage of horse-driven plows. A one-horse plow, as pictured here, would still be considered an extravagance for nearly all winemakers in the 1920s as the horse itself could cost anywhere from $50 to $150 if trained and the cost of the plow was nearly equal to that of the horse. The other major dilemma for those who might chose to purchase a tractor was the inconvenience of mechanical maintenance. There were not many garages or mechanics in the early stages of American automobile manufacturing. Additionally, fuel had to be purchased and stored in great quantities, which were two more expenses that were beyond the reach of the winemakers at this time; however, the end of the horse-drawn era was just around the corner. (Courtesy of UC Davis Shields Library Archival Collections)

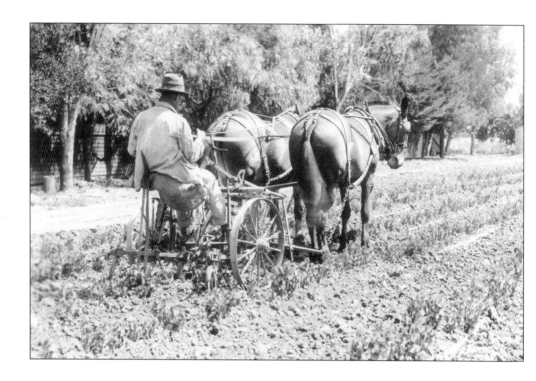

The two-horse cultivator appears to be more of a choice form of operation as the professor is actually seated instead of walking behind the blade as in the case of the single horse implement. And if two horses are better than one, well then three horses must certainly be even better yet! (Courtesy of UC Davis Shields Library Archival Collections)

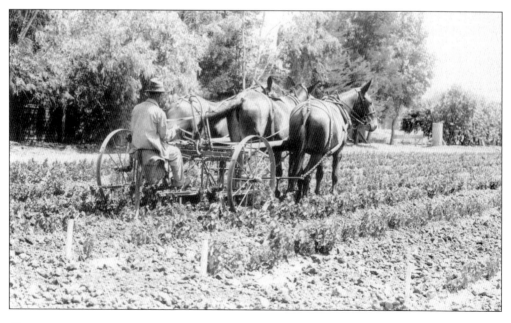

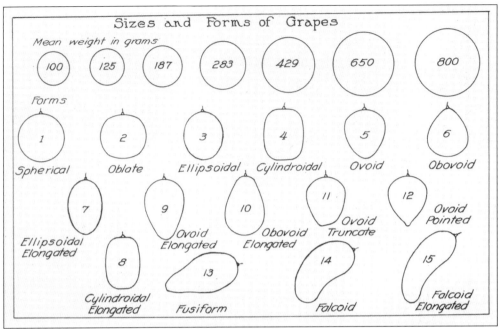

In this 1923 reference card the various sizes and shapes of the more commonly planted wine grapes must have helped many a viticulture student in the early stages of their education at the University of California. According to this card, it appears as though the student was responsible for at least 15 different grape forms with weights that ranged from 100 to 800 grams. (Courtesy of UC Davis Shields Library Archival Collections)

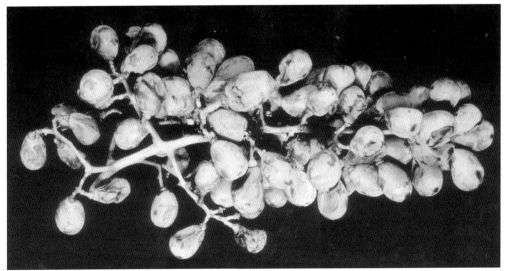

This is a classic example of "don't let this happen to your vineyard!" Seriously, UC viticulture studies have always included a significant amount of attention given to the real threats to the vineyards, which have included the dreaded phylloxera and as this picture demonstrates, Almeria Spot, which leads directly to a poor harvest year to say the least. (Courtesy of UC Davis Shields Library Archival Collections)

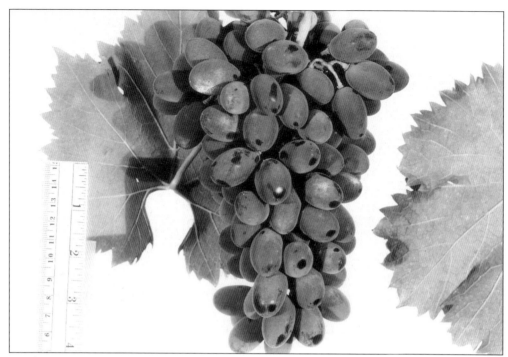

For the novice in viticulture, these 1941 UC Davis viticulture records are of four different wine grape bunches, which in professional terminology are tetraploidy. These grapes are the Cornichon variety. (Courtesy of UC Davis Shields Library Archival Collections)

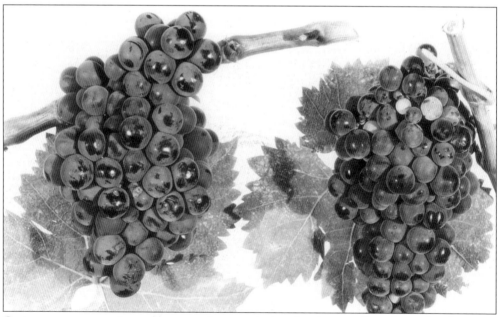

Carignane grapes, as pictured here, produce a red wine that is generally only produced in great quantities in California and France. Though quite common in the early half of the 20th century, much of the Carignane has been replaced by Trebbiano and lately Barbera, both fine varieties for red table wine. (Courtesy of UC Davis Shields Library Archival Collections)

Most contemporary wine enthusiasts will no doubt be familiar with this robust, California "big red" variety—Zinfandel, truly one of California's most matchless varieties and most interesting looking vines. It is easy to spot a Zinfandel vineyard over most others, even in the dormant winter, as this hearty plant is in less need of support than the others are and therefore is seen "standing alone." (Courtesy of UC Davis Shields Library Archival Collections)

At the other end of the wine tasting spectrum one will assuredly encounter the wine made with these white grapes, the Sauvignon Blanc, which currently is a close second to the king of white premium wines, Chardonnay. In the 1970s Robert Mondavi took this already popular wine, changed the process around a bit by taking out some of the residual sugar and added a touch of Semillon and invented a new masterpiece: Fume Blanc. (Courtesy of UC Davis Shields Library Archival Collections)

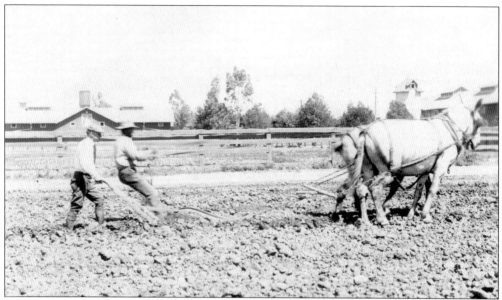

The viticulture students at the University of California were able to gain first hand experience at all points of the winemaking process, from soil preparation and planting through the harvest and crush. This was in addition to the challenging academic curriculum which focused on botany and pest control. In this 1923 picture two students are preparing the soil for planting, and it appears as though the two-horse team might have been a bit too much for one man to handle.(Courtesy of UC Davis Shields Library Archival Collections)

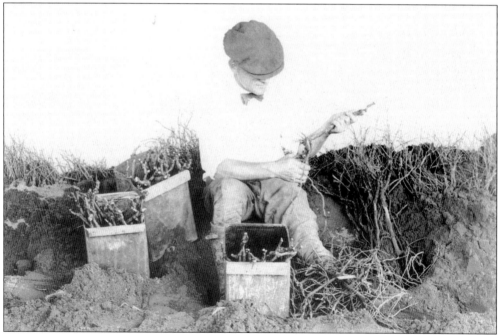

Before the vines can be planted in the soil a final check is performed, making sure that at the very least these are the intended grapes for this particular vineyard. (Courtesy of UC Davis Shields Library Archival Collections)

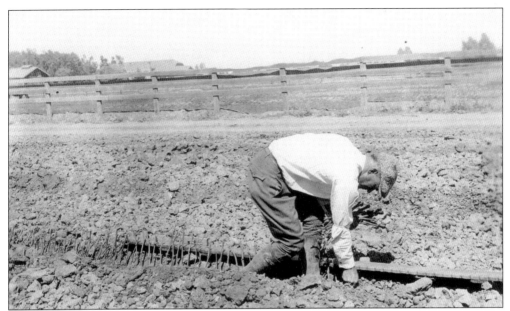

Probably the most backbreaking part of the planting process is the insertion of the grapevine into the soil itself. The process recorded in this 1923 photo has not changed much since. As the 1990s proved to be one of the more prolific decades for planting new vineyards throughout Napa County, this scene was witnessed on a daily basis. (Courtesy of UC Davis Shields Library Archival Collections)

This is the fully planted vineyard—now the long process of growing, harvesting, and crushing the grapes is next, all before the winemaking fermentation process back at the winery. (Courtesy of UC Davis Shields Library Archival Collections)

As the vines go through the growth process, much attention is given not only to water management, but also pest control. UC Davis students and researchers have produced many pesticides over the past century that have allowed the winemakers of the Napa Valley to go through each year nearly worry free. The latest threat, the Glassy Winged Sharp Shooter, has the attention of the growers and the University of California. (Courtesy of UC Davis Shields Library Archival Collections.)

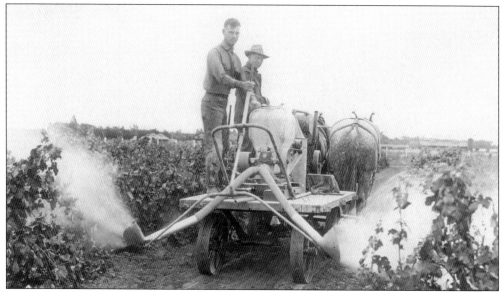

The innovations of the latter part of the 19th century lingered into the first few decades of the 20th. In this 1924 instructional card, two men operate a two-horse drawn blower, attempting to rid the vineyards of nasty pests that not only devour the grapes, but can also fully destroy the vines. Though it appears comical by today's technological standards, this mechanized blower had once been considered cutting edge. (Courtesy of UC Davis Shields Library Archival Collections.)

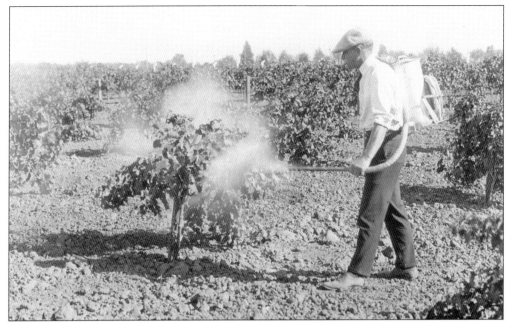

This young man was demonstrating for the UC photographer, probably his professor, how to operate the one-man, manual blower. Shouldn't he have worn some sort of protective mask? (Courtesy of UC Davis Shields Library Archival Collections)

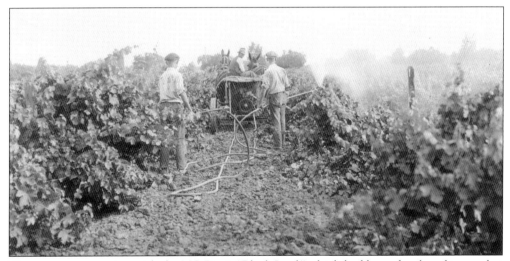

These men are spraying with the UC Davis "Black Leaf," which had been developed to combat those pesky insects that fed on the leaves of the grapevines. The utilization of a tracker not only allowed the sprayers to run more than one line, but they could work in the fields longer as a much greater reservoir of the Black Leaf could be carried into the vineyards. (Courtesy of UC Davis Shields Library Archival Collections)

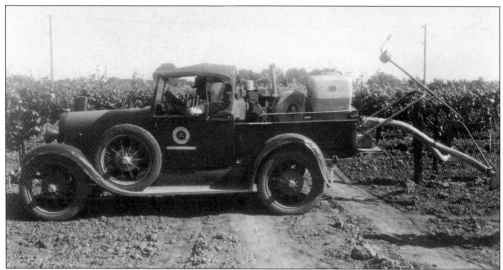

Henry Ford's innovations helped the Aggies as well! In this 1934 picture the UC Davis viticulture students utilized the latest technology with this Ford Model A utility vehicle, one of the earliest ancestors of the modern SUV hard at work. (Courtesy of UC Davis Shields Library Archival Collections)

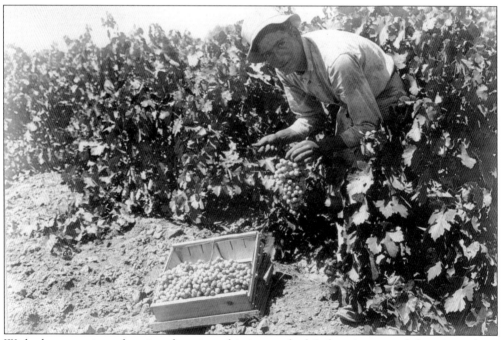

With the exception of tasting the wine, this is everybody's favorite part of the winemaking process: the harvest. As the spring and summer growing seasons pass by, autumn marks the time for the collection of the grapes off of the vines. This fellow appears to be filled with enthusiasm and anticipation of tasting the fine wine made with these grapes. This instructional card indicates that the 1924 harvest took place on July 17, a bit early by most standards. Perhaps the professors at UC Davis were trying out innovative growing methods that year. (Courtesy of UC Davis Shields Library Archival Collections)

This harvest class has encountered the dreaded phylloxera bug on their vines. Maybe someone forgot to spray this particular section of the vineyard in 1923. (Courtesy of UC Davis Shields Library Archival Collections)

Those are some impressive tetraploidy specimens that this incredibly youthful co-ed has in her hands. (Courtesy of UC Davis Shields Library Archival Collections)

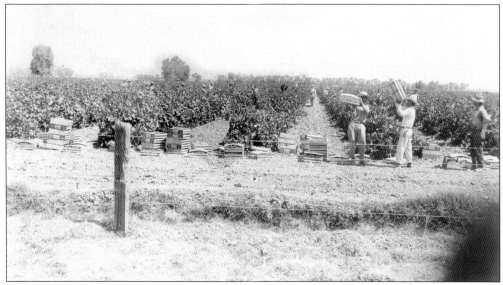

With the grapes picked and placed into the crates, the next step is to load them onto the waiting trucks. (Courtesy of UC Davis Shields Library Archival Collections)

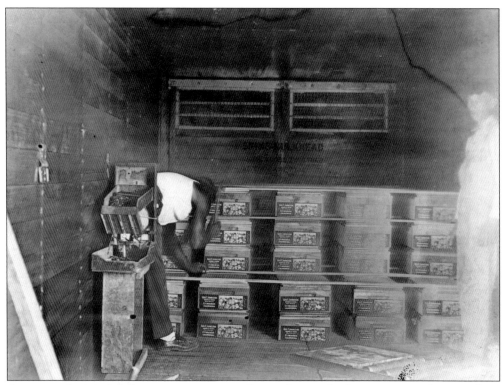

As any professional delivery person can testify to, there is both a science and an art form involved in the proper methodology of loading a truck. Safe transportation of the produce and easy unloading are the goals, and in this 1924 instructional card, it looks as though UC Davis viticulture students have mastered the process. (Courtesy of UC Davis Shields Library Archival Collections)

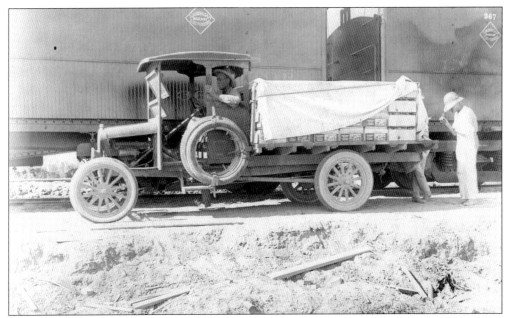

Luckily for the winemaking business and all other forms of agriculture in the state of California, the railroad lines were already in place by the time large scale growing became the standard in the early 20th century. (Courtesy of UC Davis Shields Library Archival Collections)

After the grapes have all been picked, sorted, crated, and shipped, the sorting and crating facilities are thoroughly cleaned and once again go dormant until the following fall harvest. (Courtesy of UC Davis Shields Library Archival Collections)

Persistent foam inside of the wine bottle is a genuine concern. The cause of foam can be many different things. One such possible cause could be the presence of bacteria, but more often, persistent foam occurs when impurities exist. To combat these ailments, advances were made in each stage of the winemaking process. (Courtesy of UC Davis Shields Library Archival Collections)

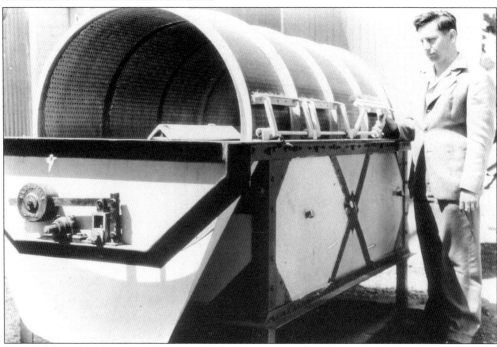

Pictured here in this 1941 photo was one of the most technologically advanced macerators of the time. (Courtesy of UC Davis Shields Library Archival Collections)

Once the harvest is complete, the next stage is proper pruning. (Courtesy of UC Davis Shields Library Archival Collections)

Before the cloning and subsequent planting of new vineyards, proper disinfecting must take place as this 1923 picture demonstrates. Without it, an entire vineyard might fall to unwanted and destructive pests. (Courtesy of UC Davis Shields Library Archival Collections)

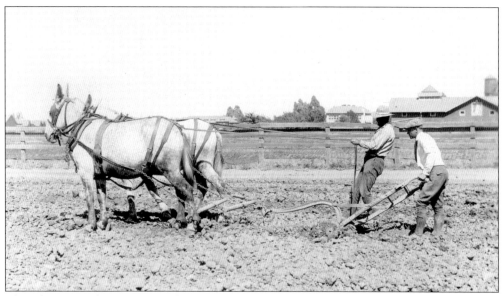

Then the entire planting process begins again with the great joy of tilling and preparing the soil. It is hard to tell from this 1923 picture if the horses are on a break or if the men behind the plow have not yet figured out how to operate this complex piece of machinery. (Courtesy of UC Davis Shields Library Archival Collections)

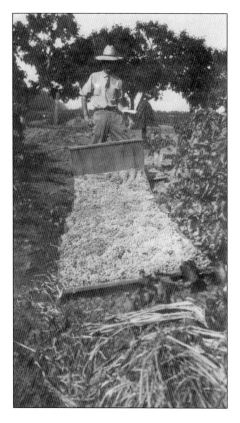

In this interesting 1916 instruction card, one of the researchers at Davis displays a successful grafting of one of the plants. (Courtesy of UC Davis Shields Library Archival Collections)

As no winemaker cares to have their enterprise go the route of these ghost wineries of Napa County, all stages that go into the process of making wine are of the utmost importance—even politics—lest one falls into ruin. (Courtesy of UC Davis Shields Library Archival Collections)

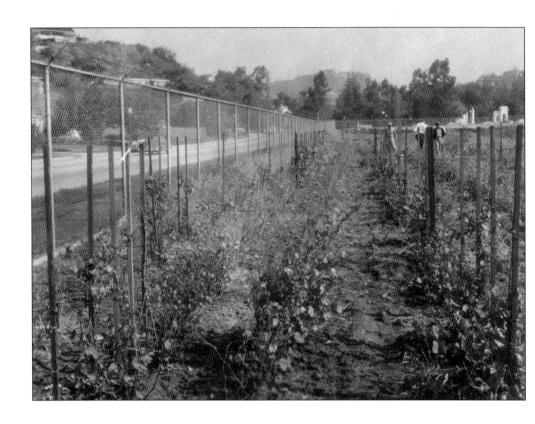

Though this c. 1950s photo of UC Davis grapevines gives the impression that those in the "Ag Town" did not enjoy the fruits of their labor, a look into one of the local convenience stores clearly demonstrates that even the serious viticulturists were aware of National Wine Week. (Courtesy of UC Davis Shields Library Archival Collections)

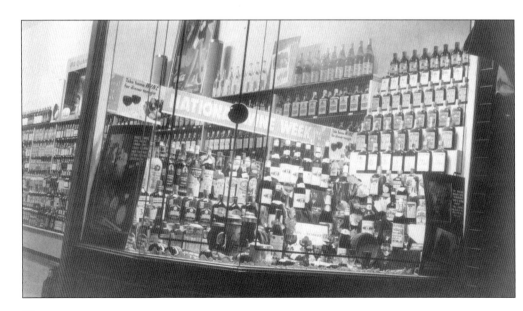

Three
THE 20TH CENTURY AND POST-PROHIBITION RESURGENCE

The beginning of the 20th century appeared to be a continuation and expansion of the Napa County wine industry. During the last 40 years of the 19th century, growth and success seemed to characterize the experience of this newly developed wine region. Barring any extreme natural disaster, it was a logical conclusion that this nearly vacant valley would be a most promising location for any who might venture into the wine making business, and up until Prohibition, this type of speculation, along with dedication and hard work, did lead many businesses to the American dream. Just as Franklin Delano Roosevelt had promised during his first campaign for the White House—Happy Days Are Here Again! Prohibition, which had been put in motion by Woodrow Wilson, in no small measure to qualm the Women's Christian Temperance movement, was finally repealed in 1932. Generally regarded as one of the greatest legislative blunders in the history of the U.S., Prohibition did not stop or even seriously slow down alcohol consumption or manufacturing as had been the intent of those "dry" folk that supported its passage; rather, it destroyed the lives of thousands of Californians who worked in the wine industry as well as the other allied beverage fields. The only real benefactors were the bootleggers and booze-runners who came to form the heart of organized crime in America. Thankfully Prohibition did end, and quite soon thereafter the Napa Valley wine industry picked up where it had left off. In this c. 1900 picture a team of men are cutting down a giant redwood. Not only are these men making room for more vineyards, they are also supplying the much needed lumber that the entire San Francisco Bay Area desperately needed as the flood of immigrants continued to pour into the region. Most people today would associate the name of the lumber company in this picture with wine and champagne, though for a generation before going into the wine-making business Korbel lumber was quite successful in its own right. (Courtesy of Korbel)

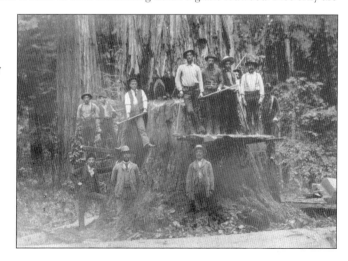

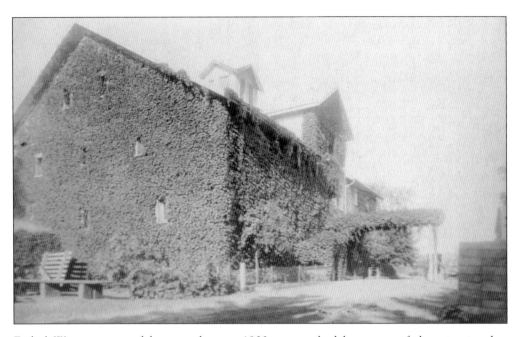

Eschol Winery, pictured here in these c. 1900 images, had been one of the wineries that experienced a long dormant period following Prohibition, though in the 1990s it has found new life. Today this once magnificent winery has been restored and is arguably more attractive than ever. (Courtesy of Giancarlo Musso)

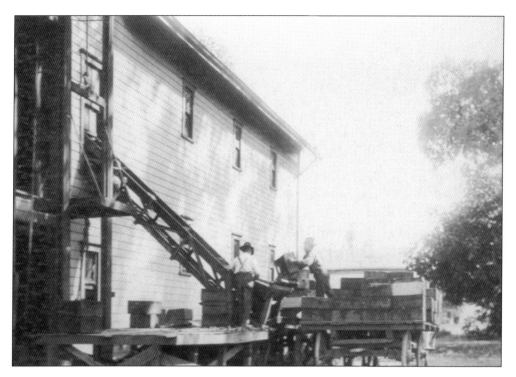

Here is the loading dock of Eschol during the early years of operation and inside the crush room during its long sleep. (Courtesy of Korbel)

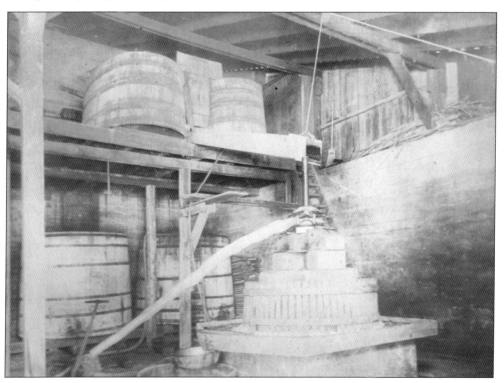

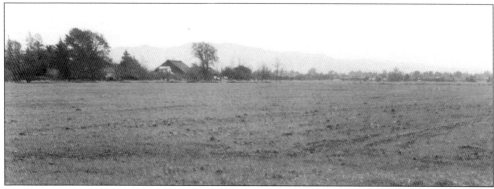

In this rare series of photos taken over a seven-year span, we can see how a section of the Napa Valley that originally had been a grassy field was transformed into a vineyard. The first picture was taken before the field had been prepared, the second the year of the planting, and the third came five years later. These particular fields were part of the vast Beringer Brothers holdings, and the pictures are from 1899, 1900, and 1907 respectively. It is quite impressive how the transformation took place. Also of note is the width between each row of vines. As technology improved and the demand for the grapes grew along with higher land prices, the vines moved closer and closer together. Today the distance between each row is nearly half of what is pictured here. (Courtesy of Beringer Brothers.)

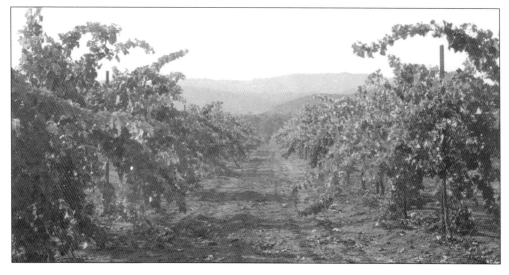

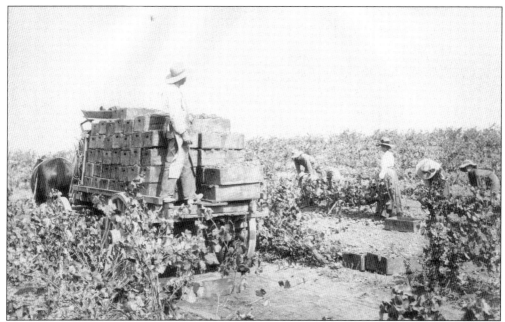

The following string of "action" photos from the Theodore Gier Winery document the picking, packaging, crush, fermentation, storage, and subsequent delivery of the wine. These pictures were taken over the course of two days, which as we all know is hardly enough time to make wine. The intent of this staged dramatization was for Mr. Gier to assemble a book of photographs, all glass-plate, which was a common hobby for those with both the time and money for such an endeavor. And in the process the Gier's have left a most valuable work of history of Napa Valley winemaking. In this first picture are the folks from the Theodore Gier Winery out in their vineyards during the 1901 harvest. Of particular interest is the Victorian attire of Mrs. Gier, even though the August and September days are usually the hottest of the year. Clearly she was a well-bred lady. (Courtesy of Christian Brothers)

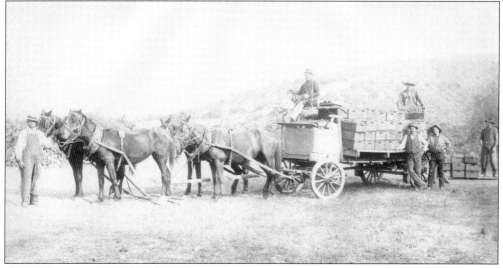

Here is the same team of workers at the Theodore Gier Winery all loaded up and getting ready to bring the grapes back for the crush. (Courtesy of Christian Brothers)

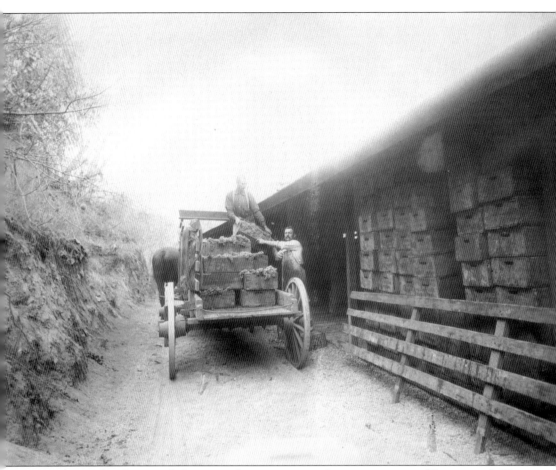
This is the Gier truck bringing the grapes into the sorting room. (Courtesy of Christian Brothers)

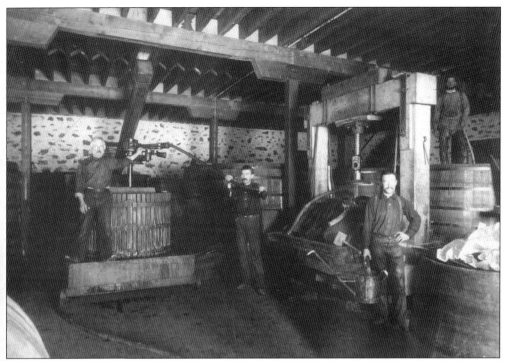
Here are the large crush vats of the Gier Winery that took the strength of at least two men to operate. (Courtesy of Christian Brothers)

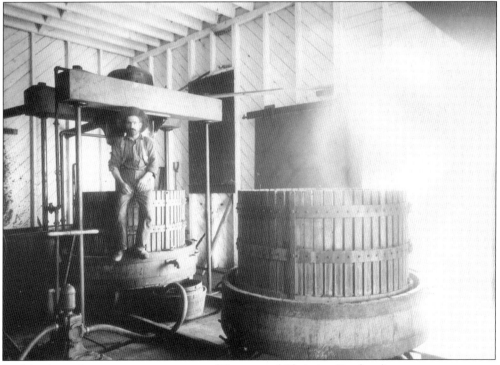
In this picture is a one-man grape press. (Courtesy of Christian Brothers)

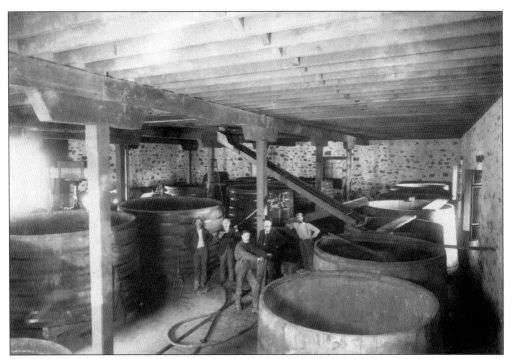

These are the large oak storage tanks, and Mr. Gier is the gentleman with the derby and fine attire standing in the center. (Courtesy of Christian Brothers)

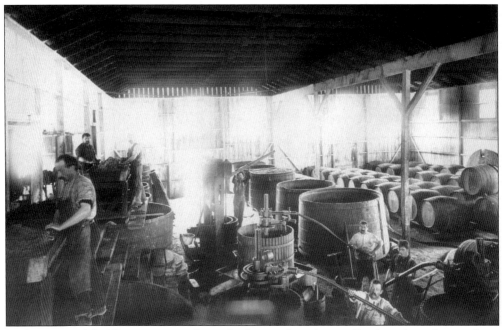

In this room of the Gier winery we have the large oak tanks, small oak tanks, a few crushers, and workers. The smaller oak barrels had actually been utilized not only as storage containers at the winery, but also as the containers for larger, wholesale orders to businesses such as bars, restaurants, and hotels. (Courtesy of Christian Brothers)

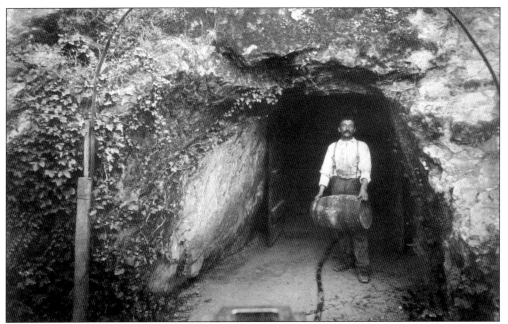

Lastly, a fine shot of one of the workers coming out of the cave with a small oak barrel en tote and judging by the ease that he is carrying this barrel, it might be safe to assume that its contents were predominantly air. (Courtesy of Christian Brothers)

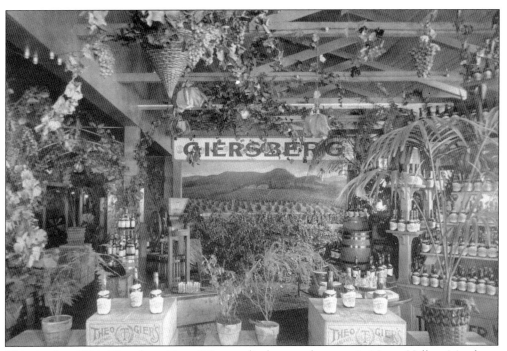

This is the 1901 Theodore Gier Winery display at that year's Napa Valley Merchant Associations annual hootenanny. Excellence in the field of winemaking is not enough to attract the eye of the consumer; fine merchandizing skills were also required. (Courtesy of Christian Brothers)

Here in these photos is the Gier family in a much more tranquil setting in the summer of 1900. (Courtesy of Christian Brothers)

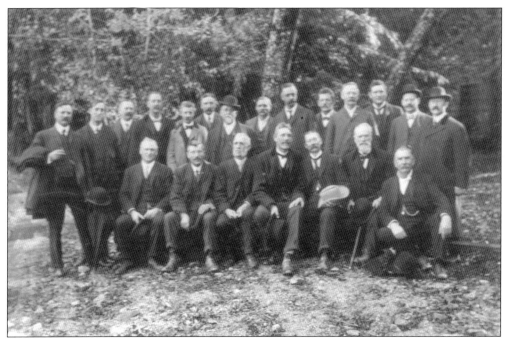

Pictured here in this commemorative photo are some the merchants of Napa County at their 1901 Merchant Association celebration. For over 100 years the Merchant Association of Napa County has been a leader in marketing the wines of the Napa Valley along with the tourist friendly atmosphere around the U.S. and the world. (Courtesy of Christian Brothers)

Due to the diligence of the Napa County Merchant Association and the wineries themselves, the small support industries such as the Rainier Club in downtown St. Helena, pictured here in the early 1950s, enjoyed many fruitful years as the tourists flooded through the valley. (Courtesy of Christian Brothers)

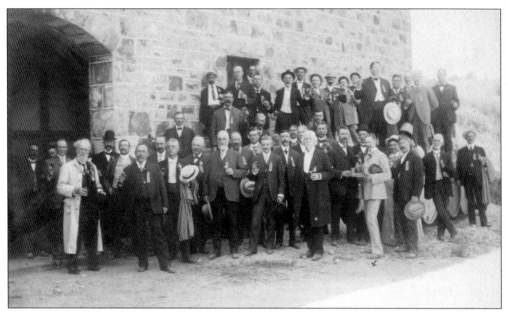

Pictured here is a more complete gathering of the Napa Merchants Association at the main entrance of Greystone in 1901. (Courtesy of Christian Brothers)

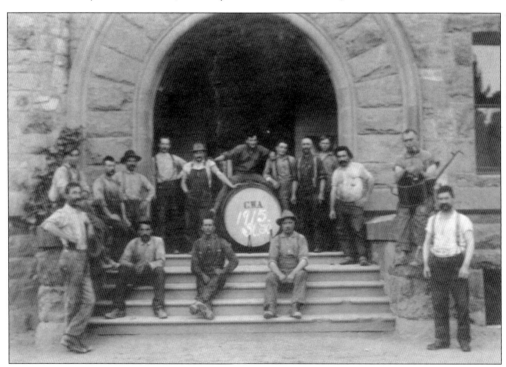

In this 1915 photo are the lead workers at Greystone at the central entrance of the main building. Anker Miller, who served for many years as the lead foreman, is the gentleman standing at the foot of the steps to the far left with his hand on his hip. Winemaker Buck Erickson is standing to the far right a few feet in front of the steps, with white shirt, suspenders, arms to the side, and with a hearty mustache, as was the style of the day. (Courtesy of Christian Brothers)

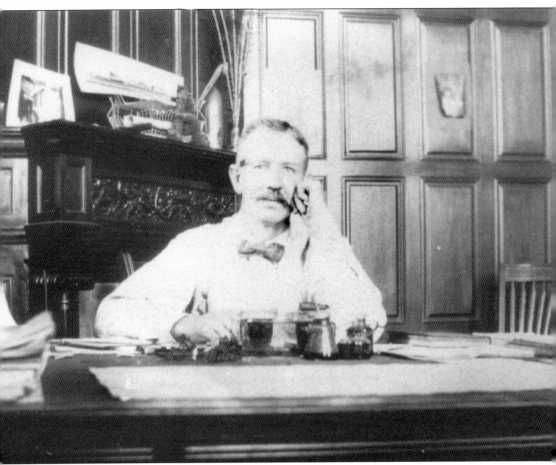

In this 1910 picture, Anker Miller is seated at his desk in the main business office at Greystone. Note the fine craftsmanship of the deep-carved wood paneled walls, remnants of a bygone era that are still visible at the Culinary Academy, which occupies the majestic Greystone today. (Courtesy of Christian Brothers)

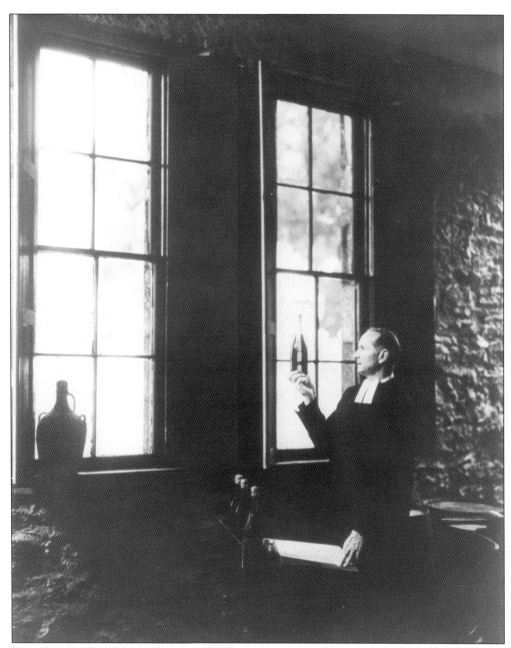
The Christian Brothers, a Roman Catholic teaching order, has a significant place in the Napa Valley wine heritage. Known around the globe for their excellence in teaching, both at the K-12 and university level, the Brothers also have as part of their tradition an excellence in wine making. Pictured here in this c.1950 picture is Brother Timothy Diener who, as many are aware, had become the preeminent force behind the success of the Christian Brothers winery, which carried the name of their order on their wine label during their many years of operation. (Courtesy of Christian Brothers)

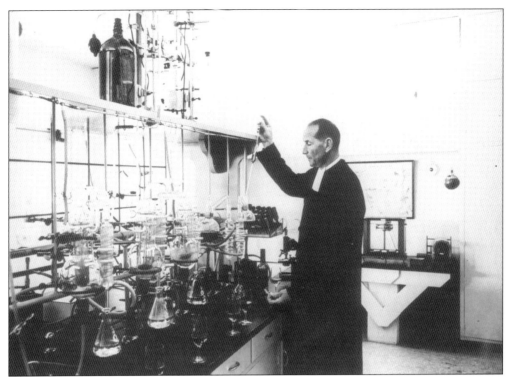

Here is Brother Timothy at work in the lab, focussed diligently upon the wines that came to bear not only the Christian Brothers name, but also Brother Timothy's as well. (Courtesy of Christian Brothers)

Most residents of Napa and the many tourists that have come through the valley over the years, will in no doubt recall the Mount La Salle Winery, pictured here in 1936, just a few short years after Prohibition. (Courtesy of Christian Brothers)

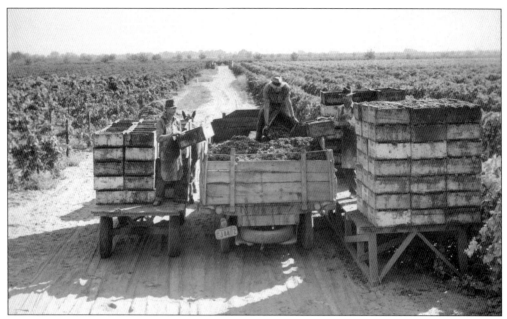

In addition to the Christian Brothers Winery on Redwood Boulevard, the Brothers also operated at their Mount Tivy location, which are pictured here in these 1940 images. (Courtesy of Christian Brothers)

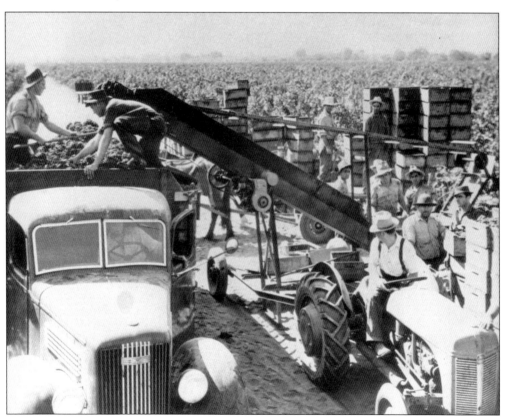

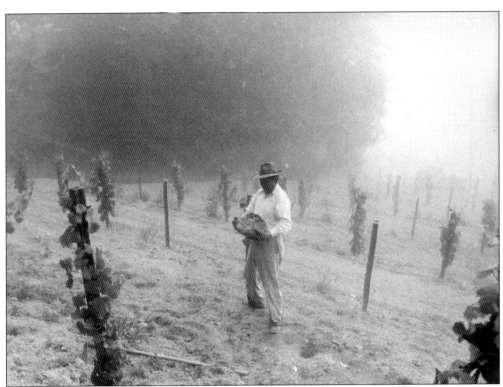

This peaceful, foggy morning in 1943 belies the great turmoil that had by then engulfed the entire globe. The fog, which is quite common in Napa during the fall, winter, and spring months, is one of the many natural features of the climate, which is most conducive to growing the wine grapes as well as the redwood trees, which need the wet, heavy fog for the majority of the water which feeds the ancient, mighty giants. (Courtesy of Christian Brothers)

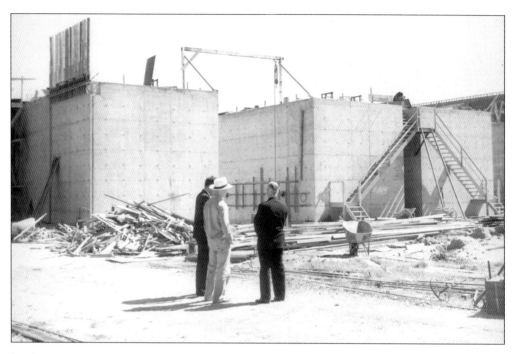

In these two 1946 pictures, Mount Tivy Winery is receiving its much needed new wine fermentation tanks. Mount Tivy, like all the other wineries throughout California, could not expand or update during the war years due to the rationing that was required to aid in the war effort. (Courtesy of Christian Brothers.)

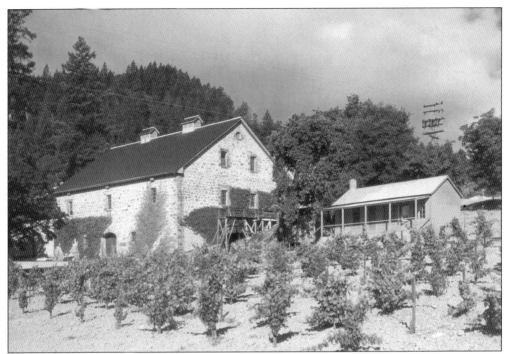

Here is the Mount La Salle Winery in the same year the U.S. entered into World War II, 1941, just months before December 7—the date that in the immortal words of Franklin Delano Roosevelt, had come "to live in infamy." (Courtesy of Christian Brothers.)

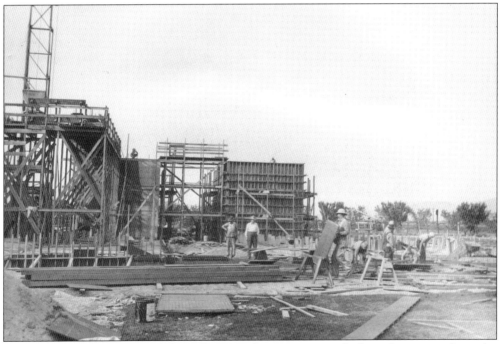

In this 1938 picture is the old sherry house and tasting room, which no longer stands on the property. (Courtesy of Christian Brothers.)

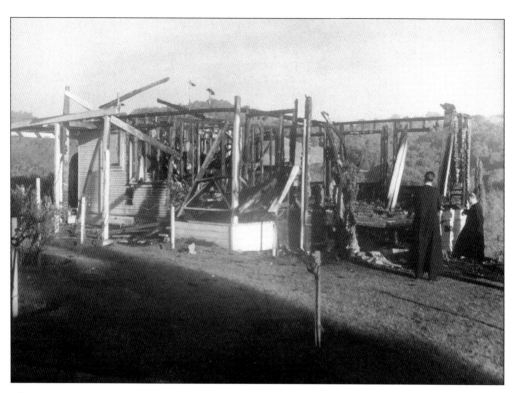

The images record the tragic fire at Mount La Salle in 1959. (Courtesy of Christian Brothers)

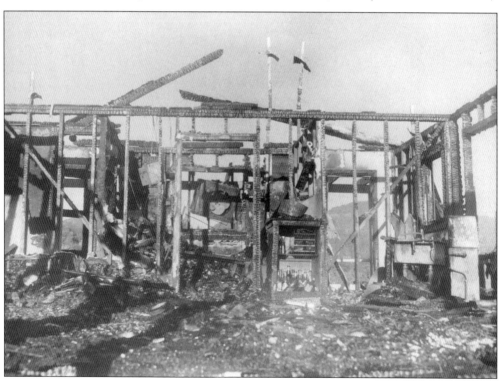

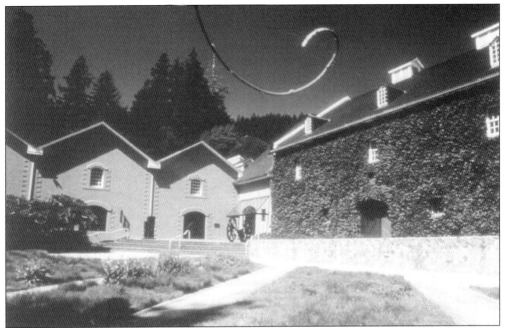

In 1982, Swiss-born Donald Hess arrived in the Napa Valley and began his winemaking enterprise after originally focusing on the expansion of his mineral water business. The first label for Mr. Hess was the Hess Collection, a line of fine wines named for the fantastic art collection of the winemaker that is on display at his winery and tasting room and is open to the public. (Courtesy of Hess Collection)

Mr. Hess is pictured here in one of his galleries at the Hess Collection. In 1986, as the Christian Brothers began to scale down their winemaking business, Hess purchased their historic Mount La Salle winery. In 1989, Mr. Hess introduced a second line of wines, Hess Select, after his vineyard holdings had grown to accommodate such an expansion. (Courtesy of Hess Collection)

Truly one of the most impressive private art collections that is on display for the general public in the state of California, the Hess Collection is a must-visit for all those who come into the Napa Valley. The impressive collection is quite eclectic, and one should budget sufficient time in order to see each of the galleries, as well as the impressive winery and grounds. (Courtesy of Hess Collection)

The tasting room at the Hess Collection is the first and the last stop for those touring the facilities. (Courtesy of Hess Collection)

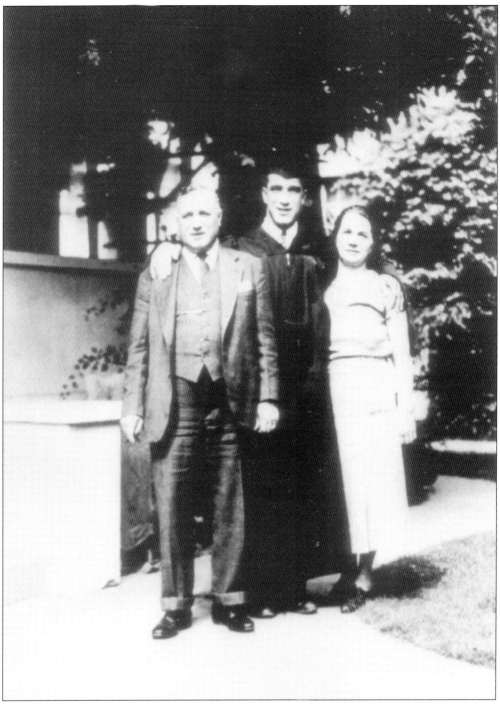

In 1937, a young Robert Mondavi, pictured here with his proud parents, graduated from Stanford University and transformed the Napa Valley wine industry the next day. Well, that might not be exactly true, though the only fallacy in that statement is that Mr. Mondavi began the day after his graduation. It was, after all, six years prior to his family's purchase of a certain historic Napa Valley winery. (Courtesy of Robert Mondavi Winery.)

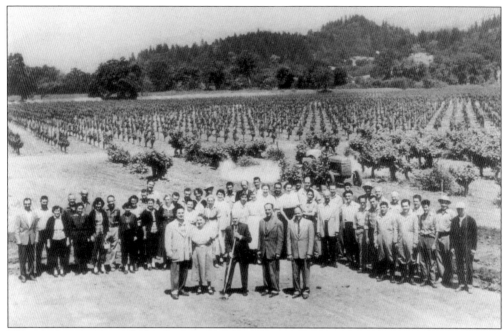

This 1943 picture records the date that the Mondavi family purchased the historic Charles Krug Winery and Vineyards. Cesare Mondavi is holding the groundbreaking shovel and Robert is to his immediate left; 23 years later Robert would open his own winery. (Courtesy of Robert Mondavi Winery.)

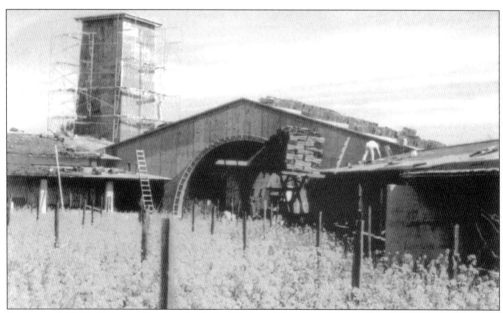

In the mid-1960s Robert Mondavi built his "Robert Mondavi Winery" in the Napa Valley town of Oakville. And as most wine-historians agree, the founding of the winery that bears his name is the beginning point of a new age in not only Napa and California winemaking, but in winemaking the world over. This image records the final stages of construction of the Robert Mondavi Winery in 1966. (Courtesy of Robert Mondavi Winery.)

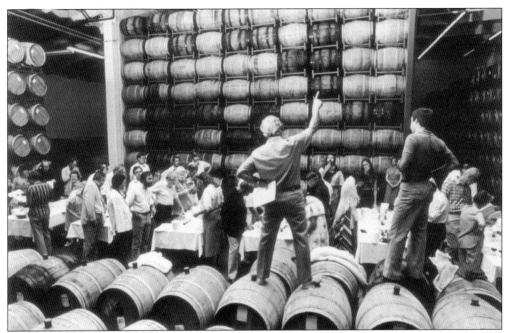

Mr. Mondavi is pictured inside the barrel room of his winery with son Michael in this 1970 image. With all of those barrels, it appears as though Mr. Mondavi's winery had been well on its way even in the early years. (Courtesy of Robert Mondavi Winery.)

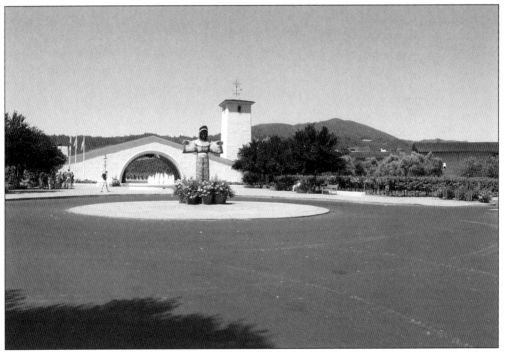

The Robert Mondavi Winery is not only the home of one of the finest lines of wine in Napa, it has also been the location of music festivals and is in its own right a center for art, just as the Hess Collection.

By the time this photo of Robert Mondavi was taken in 1980, he had already accomplished more than most winemakers, although he was essentially just getting started. In the year prior he formed a relationship with another winemaker that would make winemaking history, again. (Courtesy of Robert Mondavi Winery)

This historic 1979 photo commemorates the business partnership of Robert Mondavi and Baron Philippe de Rothchild, from which the genesis of the Opus One Winery came. (Courtesy of Robert Mondavi Winery)

Located across Highway 29 from the Robert Mondavi Winery, Opus One opened in 1979. The goal of the two proprietors was simple: create the greatest fine wines available on the face of the earth. In just a few short years, Opus One was on every wine connoisseur's list and has remained there ever since. The architectural design of Opus One is difficult to describe, as there are no other wineries that can be compared to it. Visible from the road, the actual height and scope is deceptive from a distance. As you drive down the long, straight entrance the magnificence of the design is literally overwhelming, and simply should not be missing from any serious Napa wine enthusiast's list of places to spend time at while in the valley.

Robert Mondavi's list of accomplishments in the Napa Valley does not end with Opus One. Just a few miles west of the Robert Mondavi Winery and Opus One, down the Oakville Grade or Oakville Cross Road heading towards Mt. Veeder, lies La Famiglia di Robert Mondavi, the winemaker's latest installment.

La Famiglia di Robert Mondavi delivers one of the most captivating views of the Napa Valley. The winery and tasting room itself is set in the traditional Mediterranean design. La Famiglia opened just a few years ago and promises to be one of the most watched ventures in the Napa Valley.

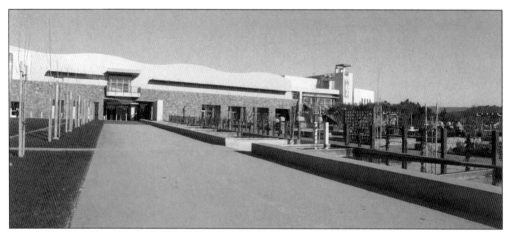

On November 18, 2001, Copia: The American Center for Wine, Food, and the Arts opened. Located at 500 First Street in the city of Napa, and founded by Robert and Margrit Mondavi, Copia was designed to be "like no other place in the world." The 80,000 square foot building is made of stone, metal, and glass and was designed by architects James Polshek and Richard Olcott. This picture was taken just prior to the opening day, and as visitors will undoubtedly notice, in just the first year alone the gardens at Copia rival those anywhere in the world. Copia represents the Mondavi family's commitment to not just the food, wine, and arts of the winemaking communities of the Napa Valley and the other winemaking regions of California, but also to accessible public education. Classes are continually offered in the areas of food preparation, gardening, and design. The instructors are not only world-class experts in their respective fields; they are also patient educators that share the Mondavi's egalitarian beliefs. A visit to Copia can be either a short one-hour visit or an all-day experience. In either case, remember to bring a camera. Copia is literally overflowing with great photo opportunities.

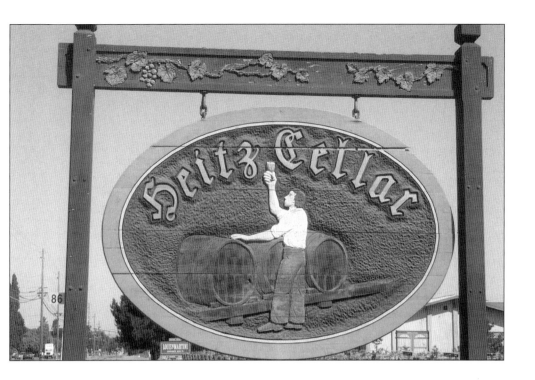

Heitz Wine Cellars was another of the post-1950s wineries that came to life in the Napa Valley. Founded in 1961 by Joe Heitz, the winery has produced some of the finer wines that have come out of California since its earliest days. Located along Highway 29, this small but earnest winery has impressed most and disappointed none, and is certainly worth a visit and a tasting.

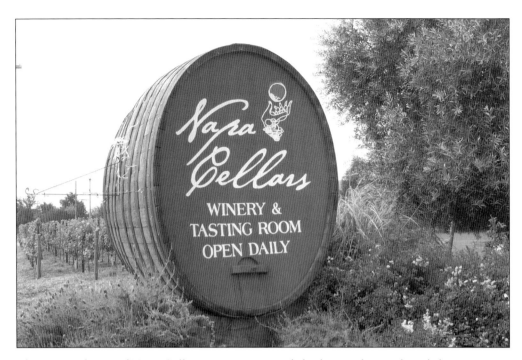

The unique design of Napa Cellars tasting room and the large oak wine barrel that acts as its entryway signage is certainly an eye catcher. As with many of the wineries in the Napa Valley, art, design, and fine winemaking seem to go hand in hand, and Napa Cellars is no exception. With a location along the west side of Highway 29, Napa Cellars has as a backdrop a sensational view of the western mountain range along the Napa Valley. Its creative yet warm and friendly environment is inviting, and the quality of the wines will in no doubt continue to build a faithful clientele.

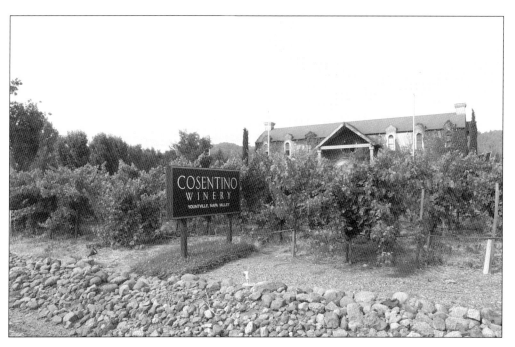

In 1980, Mitch Cosentino, a former wine wholesaler, opened the winery that bears his family's name. Initially bottling his wines under the label Crystal Valley Cellars, Mr. Cosentino found great praise early on for each of his wines, which is a rare feat for any winemaker. In 1986 he decided to change the name of his winery to Cosentino and has only witnessed successful years ever since. Another one of the "Highway 29" wineries, Cosentino has built a most attractive winery and tasting room, which has become a favorite amongst wine enthusiasts and tourists.

Located atop a small hill, the Carindale winery may escape those traveling along Highway 29, though hopefully not. A trip up to this picturesque chateau will be a rewarding experience, as the wines can be sipped while enjoying some of the most breathtaking views to fully compliment the experience.

Jake Cakebread, a former understudy of world-renowned photographer Ansel Adams, came into the Napa Valley in the early 1970s to photograph the wineries for an illustration book. Overtaken by the beauty of the land and impressed by the friendly and open nature of the people, Mr. Cakebread settled in. Founding his winery in 1973, Jake steadily increased his production, while simultaneously fine-tuning his winemaking process. One of the areas of winemaking that Mr. Cakebread has pioneered has been the barrel fermented Sauvignon Blanc, which have been, according to even some of the most difficult to impress critics, some of the finest produced in the world.

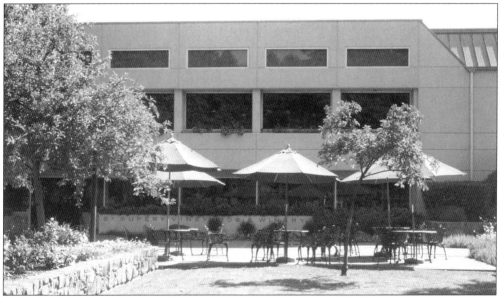

Another of the relative newcomers to the Napa Valley is St. Supèry Vineyards. Opened in 1988, the French-owned winery began its large-scale operations from the earliest moments. With more than adequate garden space and a gracious patio, St. Supèry offers a relaxing environment for wine enthusiasts. Additionally, the line of wines that St. Supèry has assembled is considered most friendly to the widest range of preferences. Though not pictured here, a recognizable feature of the winery is its quaint, Victorian, surrounding lawn and gardens.

Tony Peju had been in the Napa Valley as a tourist in 1979, and impressed with what he saw, he decided that his Los Angeles nursery business would probably not be as stimulating as a winery. In just a few short years he purchased a vineyard around Rutherford. In 1983, Tony opened his winery, Peju Province, and the magnificent grounds speak highly of his expertise in his former enterprises. Recognized today as not just one of the most beautiful wineries in the Napa Valley, but also as one of the preeminent winemakers, Peju Province has seemingly never had a poor year since its founding a generation ago.

One of the trademarks of the Peju Province winery is the fine collection of art that can be found throughout the grounds. This unique sculpture piece by the acclaimed San Francisco artist Welton Rotz is titled "Harvest Dance."

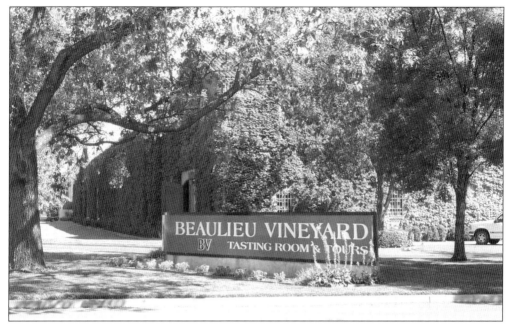

Beaulieu Vineyards has long been regarded as one of the great American wineries, and it also happens to be the first Napa Valley winery built in the 20th century—it was founded in the year 1900 by Georges de Latour. Over the course of its 100 years in the town of Rutherford, Beaulieu has stacked up a tremendous collection of awards in winemaking. It has also been one of the most visible and easy to locate of all the Napa Valley wineries due to its prominent location on Highway 29.

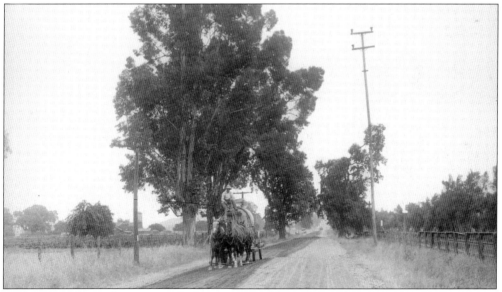

With easy access to the main road, the wagons and later the trucks of Georges de Latour were able to bring in supplies needed at the winery as well as complete easy delivery of the finished products. The meticulous nature of Georges de Latour was well known throughout the valley; he was a man focused on making great wine and not one to waste time otherwise. This picture of the Beaulieu wagon is from 1903.

Today there are actually two tasting rooms at Beaulieu: BV and the premium George de Latour Reserve tasting room pictured here. Both are certainly worth visiting, but if you only have enough time to take in one, I recommend the reserve. There are always enough friendly folk inside to take the wine enthusiast through one of the best experiences possible.

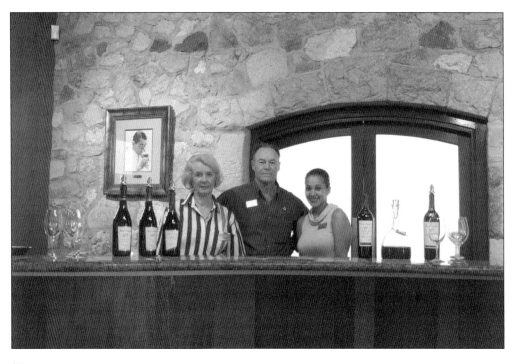

Clos Pegase, founded in 1984 by Jan Shrem, contracted the postmodernist design architect Michael Graves to design this ultra-contemporary winery. As in the tradition of many other Napa Valley wineries, Jan Shrem has decorated the lawns and gardens of the winery with sculptures that reflect the overall sentiment of his winery. Located in Calistoga, just a bit north of St. Helena, Clos Pegase has been a favorite stop since its inception nearly 20 years ago.

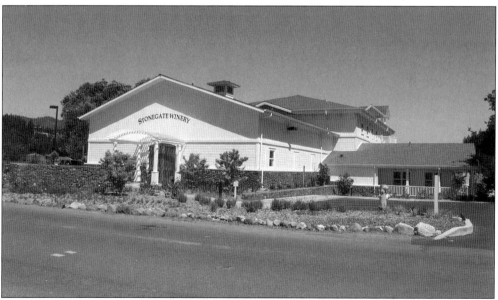

In 1969 Jim Spaulding moved his family to California and four years later opened Stonegate Winery in Calistoga. Winemaking then became a family affair as Jim's son David became the winemaker at the start of the 1980s. Now in their fourth decade, the Spauldings have enjoyed continual growth and success, and has become one of the more sought after brands today.

Bruce Markham founded the vineyards that carry his surname in 1978. Having purchased an old abandoned 19th-century facility, Mr. Markham was successful in turning out great quantities of fine wine quite early on. Within just a few short years the Markham Vineyards had a reputation for winemaking excellence that has only grown over the past 20 years.

Clos Du Val came into existence in 1972 in much the same way as many of the Napa Valley wineries in the post-1950s—quite unexpectedly. Owner John Goelet, whose ancestral heritage includes wine traders, had his business manager Bernard Portet research potential enterprises in the Napa Valley. Portet came upon a region, known as the Stag's Leap, and was immediately convinced that there was ample room for growth in the vicinity for another winery. Within its first few years Clos Du Val become recognized as a serious contender in California winemaking, first establishing its Cabernet Sauvignon, Merlot, and Zinfandel. Since the mid-1980s it has branched out successfully in the white wines, with a reputation for outstanding Chardonnay.

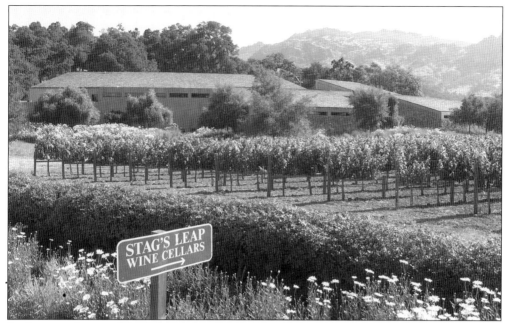

In the central zone of the Stag's Leap region exists the appropriately named Stag's Leap Wine Cellars. This highly celebrated winery was founded in 1972 by former professor of political science Warren Winiarski, who had experimented in home winemaking prior to establishing his winery. Winiarski did not just jump into the business; he first studied at and worked for the Robert Mondavi Winery for a few years before setting up his own winery. Though Stag's Leap Wine Cellars had originally been set up as a small-scale producer, 1976 brought an unexpected first place in Paris. Expansion of production had to catch up with demand, which also led to a wider range of varietals; by the 1980s the fine wines of Stag's Leap Wine Cellars were being sold around the country and across both oceans

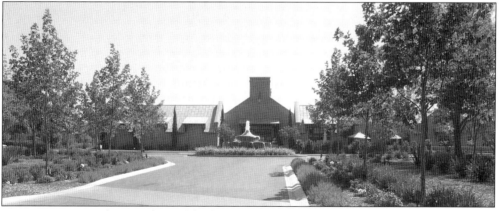

Franciscan Vineyards in Rutherford had quite a rough start, perhaps unmatched by any other Napa Valley winery in history. Founded in 1973, Franciscan went through five different owners in five years, with its sixth and current owners the Peter Eckes firm and Augustus Huneus, also the owner of Mount Veeder Winery, taking the helm in 1979. That final partnership has proven to be best yet in the winery's storied history, as Franciscan has rapidly evolved and expanded in the past 20 years. Today it is one of the more watched wineries, as in each successive year the wines continue to improve and its production continues to grow.

In 1980, former Pepsi executive Sheldon Wilson purchased land on what been known as the Chimney Rock Golf Course in the Stag's Leap District, removed nine holes, planted grapes, and thus was born the Chimney Rock Winery. The winemaking facility and all other buildings were finally completed in 1989, and today, with its unique location, handsome surroundings, and excellent wines, Chimney Rock has blossomed into one of the more popular wineries in the valley.

No visit to the Napa Valley is complete without a stop at Sterling Vineyards. Located atop a hill, and still the only winery that has a tram to bring its visitors to its front door from the parking lot below, Sterling is most definitely an eye catcher. Seen in this picture from a mile away, the Sterling Vineyards, founded in 1967, rises above the trees that surround this beautiful facility. As one might imagine, the view from atop the hill of the Napa Valley is quite impressive; however, the winery and tasting room is so attractive that many forget to walk around the grounds once they arrive. My advice to those visiting Sterling is "remember your camera!"

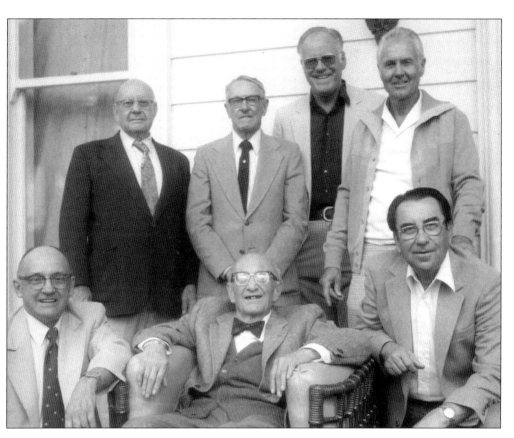

The Louis Martini Winery has been delighting wine drinkers since its founding in 1922. In 1957, Louis M. Martini turned over the operation to Louis P. Martini, who is easy to spot in this picture—he is the tallest man in the back row. He ran the winery quite successfully until turning over the helm to his children, Michael and Carolyn. Located off Highway 29, the Louis Martini Winery has been consistently drawing in tourists and wine enthusiasts now for five generations, and it does not appear to be slowing down one bit.

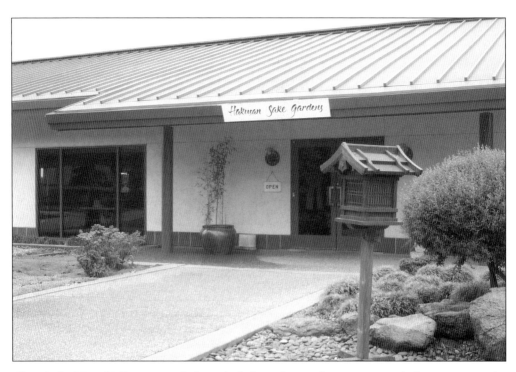

Though the Napa Valley is overwhelmingly dedicated to producing wine made from grapes, at the southeastern entry into the county one first encounters the Hakusan Sake Gardens. Sake is a wine beverage made from rice, and Hakusan is the only purveyors of sake in all of Napa County. Complete with a Japanese Zen Garden, Hakusan has consistently drawn in many tourists that are always glad for having stopped by and tasted the fine range of sake produced by Hakusan.

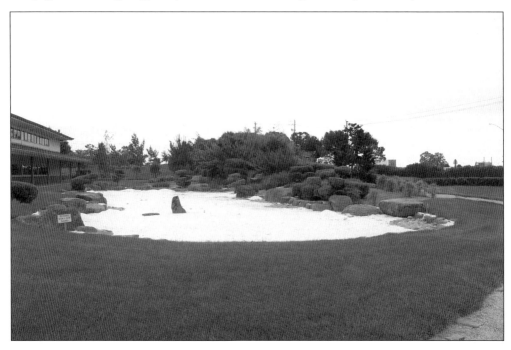

Freemark Abbey first opened its doors in 1939, after having transformed a former ghost winery into a fully operational winemaking facility. The buildings and vineyards trace their origin back to 1886, and the 19th century architecture and design of the original facility are still intact. After going through a re-birth of sorts in 1967, Freemark Abbey recognized the potential that existed in the Napa Valley tourist industry as well as the winemaking business, and thusly redesigned the entire facility by adding new buildings that would offer not only a winery, but also restaurants and shops. It was a smart move, as Freemark Abbey's additions had been exactly what the public was looking for, and currently it is clearly one of the most visited and re-visited wineries in the valley.

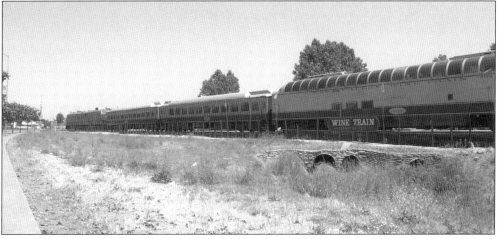

A visit to the Napa Valley should always include a ride aboard the Wine Train. Beginning at the end of the 1980s, the Wine Train not only takes its patrons through some of the most desirable spots of the entire Napa Valley, but also serves some of the most appetizing cuisine in the county.

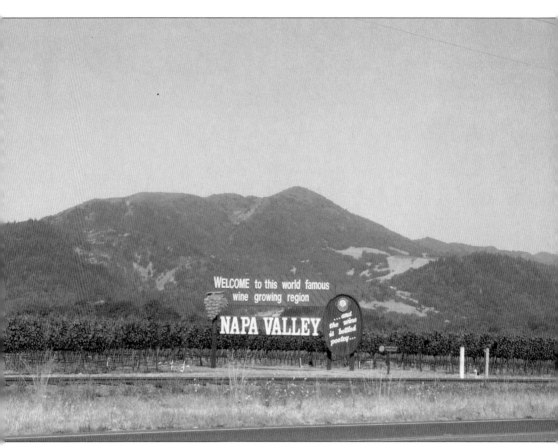

Just as the Napa Valley welcome sign reads "…and the wine is bottled poetry."

Four
EVERYBODY LOVES VISITING NAPA VALLEY WINERIES

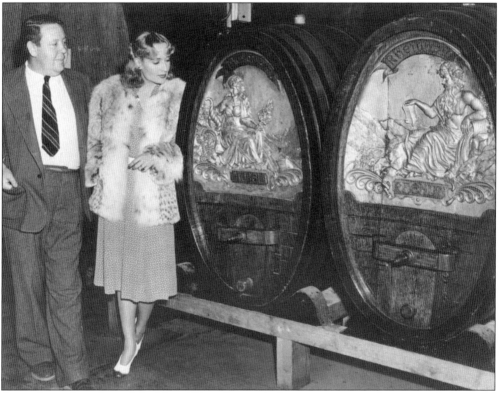

Since the earliest days of the Napa Wine Country's formation, tourists from around the world have been drawn to the magnificent natural beauty that the county offers, which of course happens to be the home of the greatest wineries in the world. There is an old saying in Napa County that goes something like this: "Wine and great hospitality were not invented in Napa County, they were just perfected here."

In this 1940 picture, Charles Laughton and Carole Lombard inspect some of the more elegant wine casks in the valley. The two had been in Napa County for the making of the film *It Happened One Night*. (Courtesy of Beringer Brothers.)

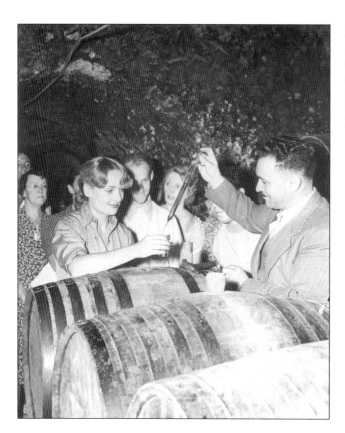

Carole Lombard, in 1940, gets a taste of some of Napa County's finest directly from the barrel, which is as good a tasting experience as it can get. (Courtesy of Beringer Brothers)

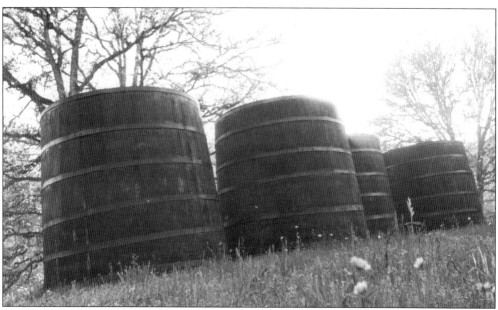

By the mid-1930s abandoned oak wine aging tanks such as the ones captured here in this 1935 picture were becoming rare. It is estimated that by the close of Prohibition there were nearly 100 of these scattered throughout the Napa Valley. (Courtesy of Beringer Brothers)

This 1934 picture is of a soon-to-open wine sales business in St. Helena. Note the NRA Blue Eagle in the window, which became an indicator of businesses that supported the National Recovery Act of the Franklin Delano Roosevelt administration. (Courtesy of Beringer Brothers)

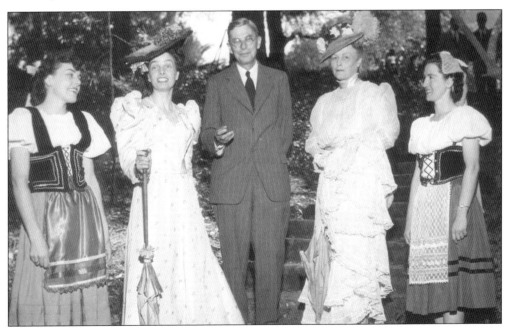

The happy fellow in the center of this 1948 picture happened to be James Conant, the much-celebrated president of Harvard and father of the SAT exam. Conant had been visiting the Napa Valley in the summer of that year, and here he is as a guest of the Christian Brothers, who happened to be educators by trade as well. (Courtesy of Christian Brothers)

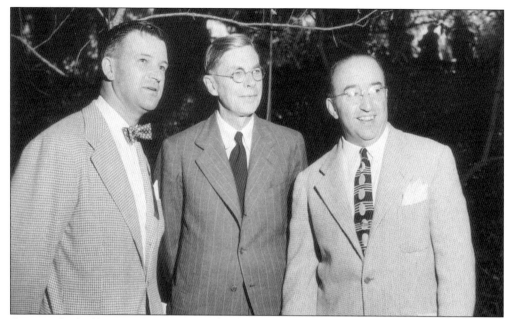

Conant, flanked by Napa businessmen, had become an international celebrity during his tenure in the top position at the oldest institution of higher learning. His radical concepts of education as well as his astute observations in the area of inner-city education problems led to many changes. His belief in "meritocracy" versus the "old-guard" as a vehicle for entry into the nation's elite colleges led him to develop a standardized test, the SAT, that would recognize potential and reward it, and as he theorized in the late 1940s, perhaps balance the scales of American society. Hopefully this serious scholar was able to relax a bit while in the Napa Valley! (Courtesy of Christian Brothers)

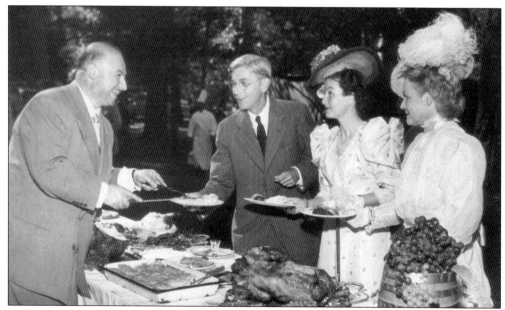

Conant appears to be enjoying the Napa Valley food, wines, and great hospitality as he is served up with the county's finest. (Courtesy of Christian Brothers)

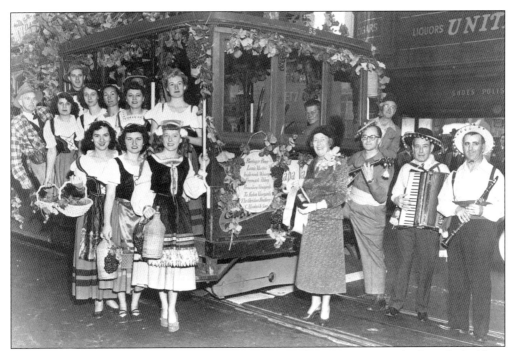

Mrs. Beringer does not appear to need any instruction on how to start a parade through the Napa Valley. In this 1940s Harvest Fair opening day celebration's lead float, complete with costumed belles, she appears to be headed in the right direction. (Courtesy of Beringer Brothers.)

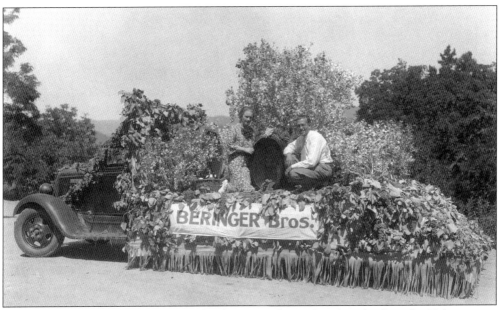

The Harvest Fair in the wine country has been a tradition that dates back to the 19th century. The harvest has traditionally marked the point at which the long, arduous periods of growth have come to an end, the grapes have been picked, and all that was left in the process was making the wine. In this 1930s picture is the Beringer Brothers Harvest Fair float. (Courtesy of Beringer Brothers.)

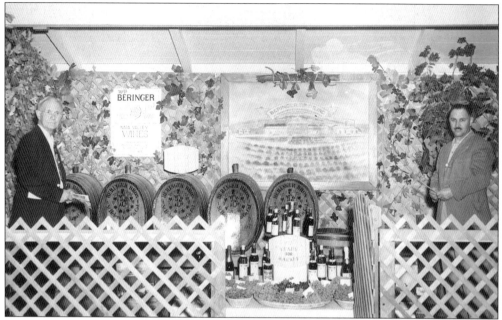

The displays at the Harvest Fairs have long been considered masterpieces of merchandizing. In this 1940 Beringer Brothers display, models of the large oak casks had been created, giving a more authentic look to the display. (Courtesy of Beringer Brothers)

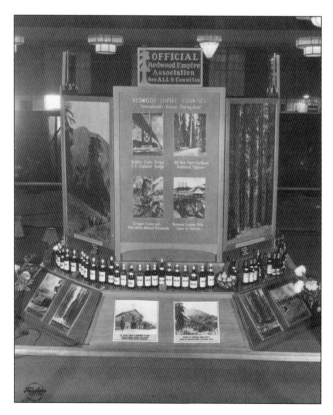

In this 1938 Redwood Empire display, winemakers from around the valley contributed bottles of their prize vintages, giving validity to the banner boast of having representation from each region of the Redwood Empire, which also happens to contain both the Napa and Sonoma winemaking regions. (Courtesy of Beringer Brothers)

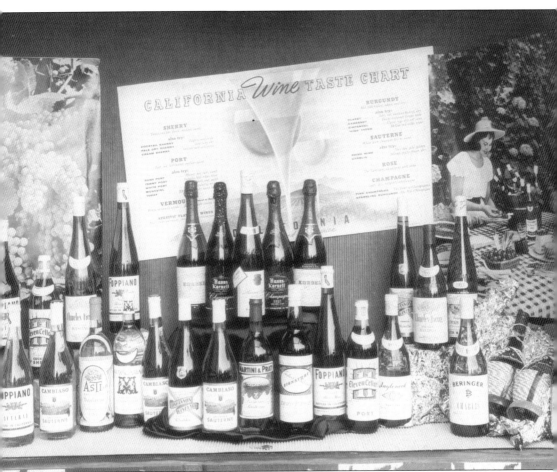

Wine tasting instruction has always been a valuable tradition. This 1930s display was dedicated to increasing awareness of the great variety of wines that was available for the consumer, even at that early point of winemaking in the Napa Valley. But of course many had to be reminded of the fine wines that the Napa County vintners had long been accustomed to producing due to the long hiatus of winemaking during Prohibition. (Courtesy of Christian Brothers)

This extravagant display at the California State Fair contains a bottle from nearly every Napa County winery, as well as a variety of the "other" fruits that have been growing in the wine country's many orchards. (Courtesy of Christian Brothers)

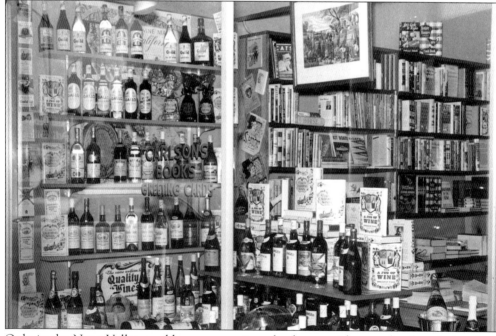

Only in the Napa Valley would one encounter a bookstore with more bottles of wine than books on display in the front window. This 1940s picture of Carlson's Books and Cards really demonstrates the dedication that all businesses had in promoting the county's winemakers, which has always been the greatest tourist draw into the region. (Courtesy of Beringer Brothers)

Boxing and wrestling came together one night in St. Helena. Pictured is heavyweight-boxing champion Max Baer seated in the "throne" created by the world champion tag-team wrestling Sharp Brothers from Canada in 1939. Perhaps these fellows had been enjoying themselves too much at the wine tasting rooms in the Napa Valley that day. (Courtesy of Beringer Brothers)

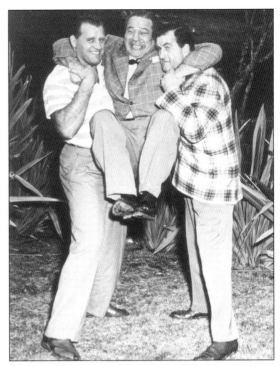

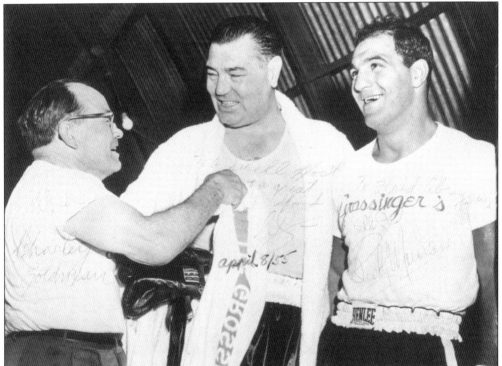

Three great names in the world of boxing were the guests of the Beringer family in the summer of 1955. Here is the legendary trainer Charley Goldman, the immortal Jack Dempsey, and the original Italian Stallion, Rocky Marciano. (Courtesy of Beringer Brothers)

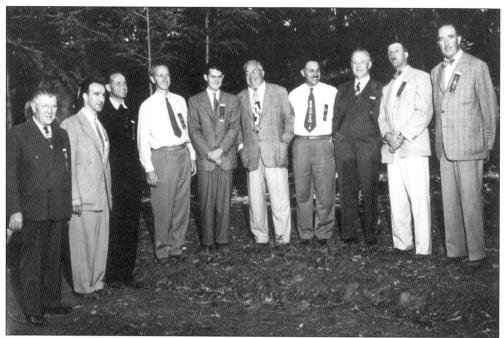

This 1956 picture contains several of the leading Napa Valley winemakers of the time, who were celebrities in their own right. There had begun at that time, not just a re-birth in the winemaking world, but a new focus on the tourists and how to make the wine country more appealing. One of the earliest and most-recognizable outcomes had been the relationship between the winemakers and other businesses, which caught the attention of the public, and ranged from entertainment and the fashion industry to international diplomacy. (Courtesy of Beringer Brothers)

Kort of California, one of the leading designers of Women's Apparel located in San Francisco, utilized the Beringer Brothers facilities for a 1956 fashion show and shoot. This lovely lady shows just how fashionable it is to be atop a few wine barrels in designer clothing. (Courtesy of Beringer Brothers)

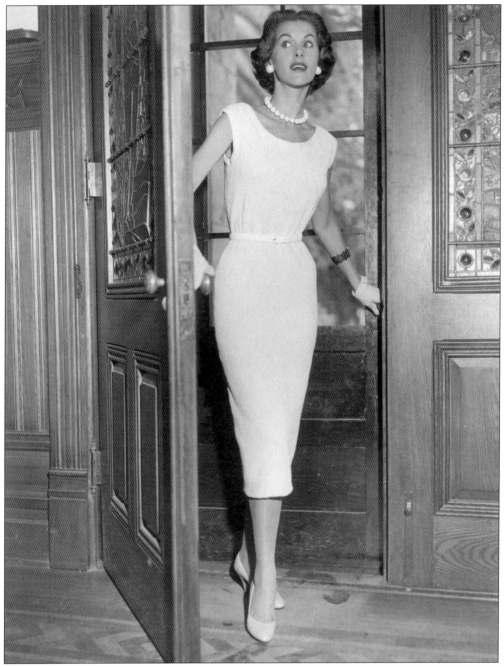

White gloves, pearls, and a seductive look must have aided in the sale of a few of these early spring dress suits. (Courtesy of Beringer Brothers)

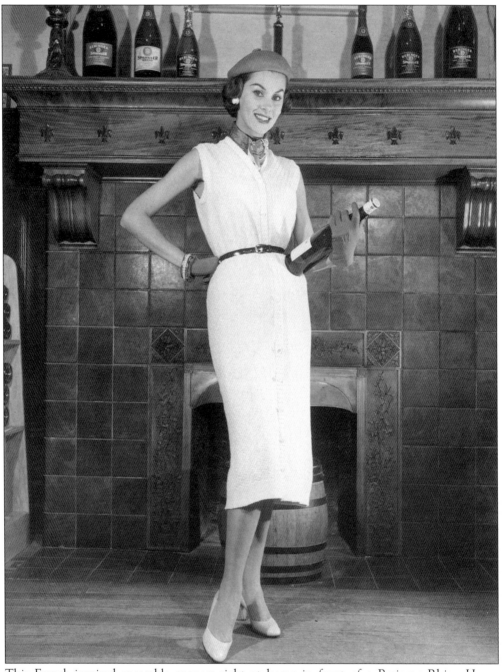
This French-inspired ensemble appears right at home in front of a Beringer Rhine House fireplace. (Courtesy of Beringer Brothers)

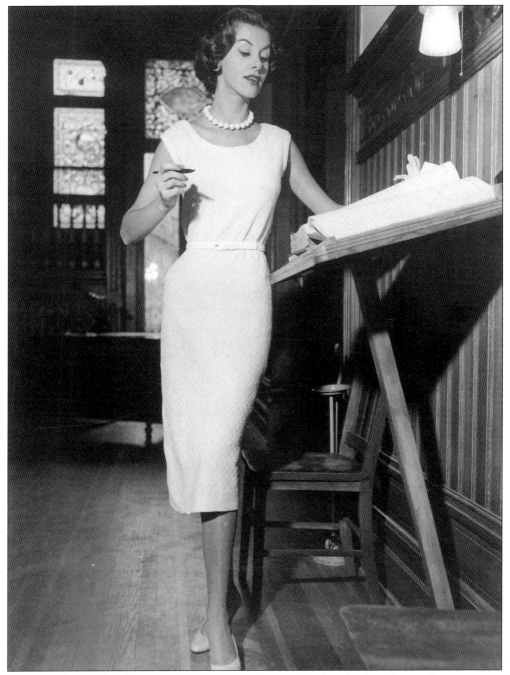

It is difficult to tell if this young lady is signing the guest book or looking for any famous names that might appear on its pages. (Courtesy of Beringer Brothers)

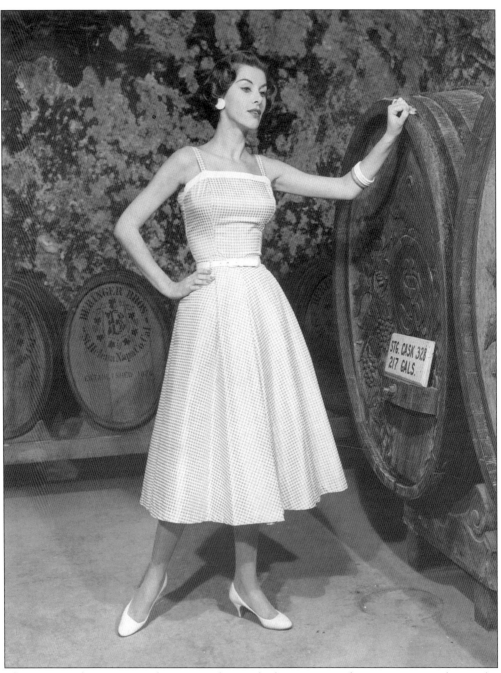

This summer dress is certainly an appealing style for a visit to the wine country during the hottest months of the year. However, down in the wine caves, the temperatures can linger in the 50s all year round. This model must have been quite disciplined, as her composure is well intact even in the cool underground caverns in such light apparel. (Courtesy of Beringer Brothers)

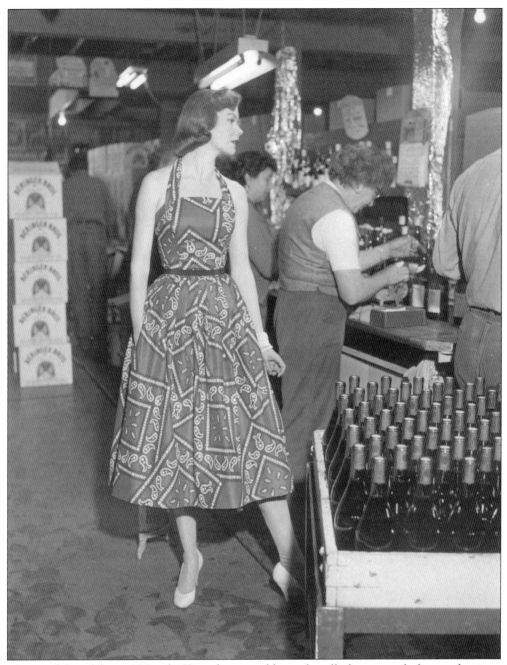

This model and her 1956-style Kort dress would not be all that out of place today in a Yountville, Rutherford, Oakville, Napa, or St. Helena market. (Courtesy of Beringer Brothers.)

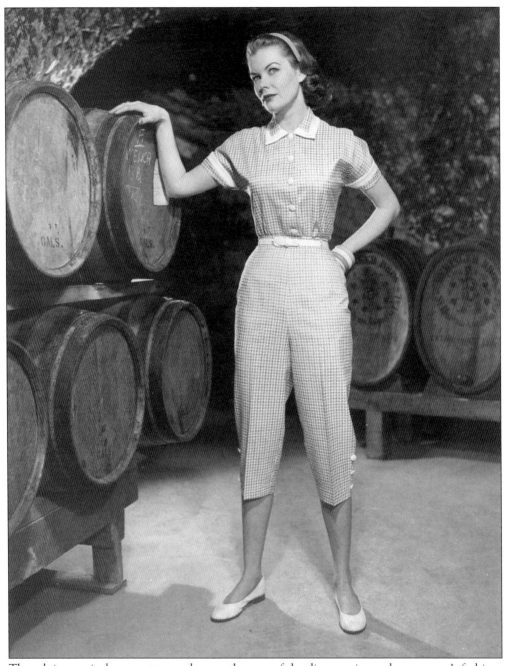

Though jumpsuits have pretty much gone the way of the dinosaur in modern women's fashion, this attractive matron might inspire a re-visiting of such vintage styles. (Courtesy of Beringer Brothers)

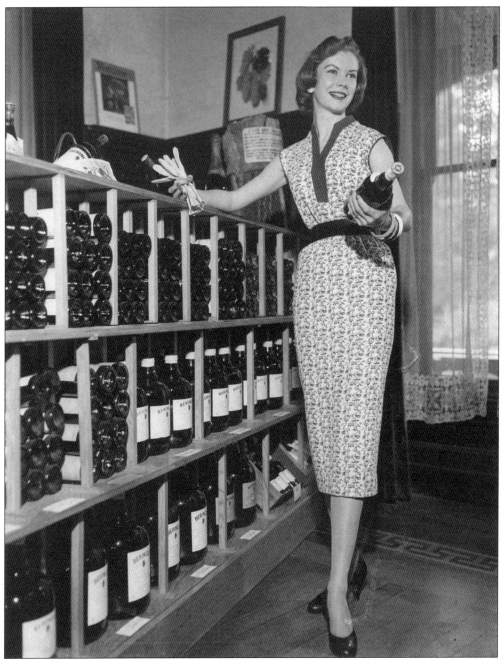
Selecting a wine never looked so glamorous as this. Here we have a winning combination: a well-dressed young lady with a fine bottle of Beringer wine. (Courtesy of Beringer Brothers)

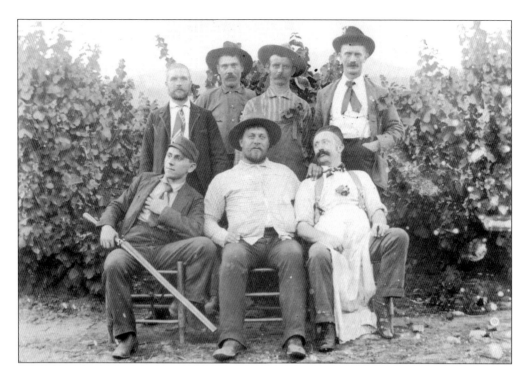

These fellows, getting ready for a hunt, probably would not have turned down a date with any of the Kort models, and as these pictures were taken in the 1890s, by the 1950s they might have actually been grandparents to a few of the girls. (Courtesy of Korbel)

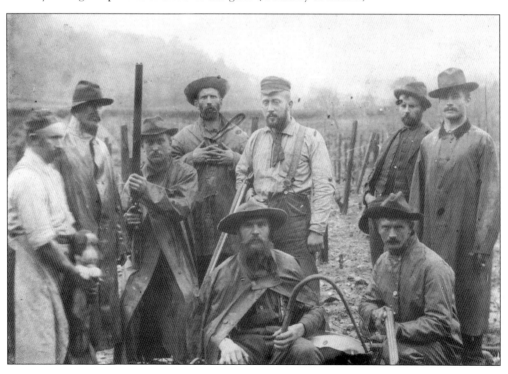

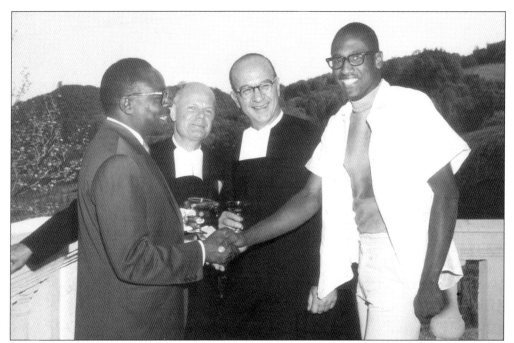

In the summer of 1961 the State Department sponsored a weeklong tour of the Napa Valley for the leaders of some of the developing African nations. The visit, though predominantly diplomatic, also had many lighter moments. It came to be termed Africa Week. In this picture is President Maurice Yameogo of the republic of Upper Volta, with Brother Gregory, F.S.C., president of the catholic order's vineyard, and a young novitiate. Earlier in the day Yameogo received an honorary Doctorate of Laws from St. Mary's College in Moraga, a San Francisco Bay Are college operated by the Christian Brothers. (Courtesy of Christian Brothers)

Pictured here are Brother Gregory and President Yameogo in front of a Christian Brothers Zinfandel vine. (Courtesy of Christian Brothers)

Here are a few of the delegates from Africa Week, September 24, 1961. Some of the attendees included the Debrah couple from Ghana, a leading farming family from that nation; Mrs. Tanimowo Ogunlesi, internationally renowned president of the Nation Federation of West African Women; and the Christian Brothers own Brother Gregory. (Courtesy of Christian Brothers)

Ed Rossi, president of the wine advisory board, accepts an award from *Sunset* magazine's Bill Lane in 1946. By the post-WWII era, the Napa Valley wineries were beginning to outsell the European vintners at home. This was quite a notable achievement given the level of respect for the French and Italian wine makers in the U.S. (Courtesy of Christian Brothers)

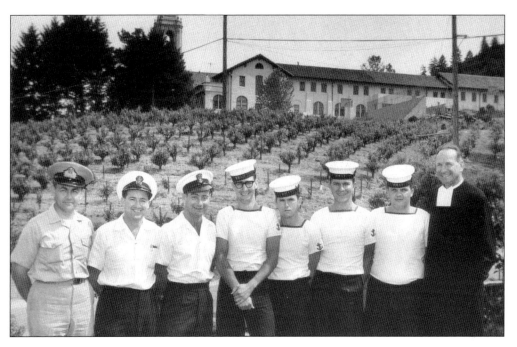

As the Napa Valley is but an hour drive from the San Francisco Bay, many tourists of that famous city find their way to the wine country. Pictured here are sailors from the former Soviet Union and Japan in the early 1960s. Though the U.S. and the USSR might have been in the middle of the Cold War, a few bottles of Napa Valley's finest would indeed help thaw out relations. (Courtesy of Christian Brothers)

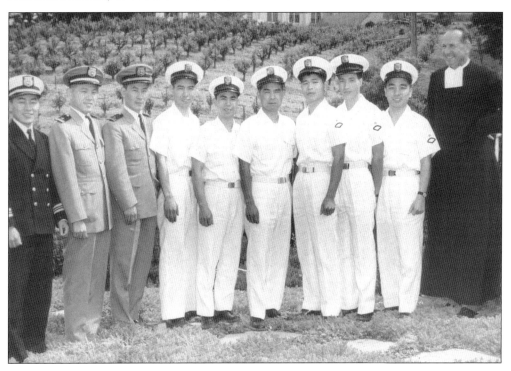

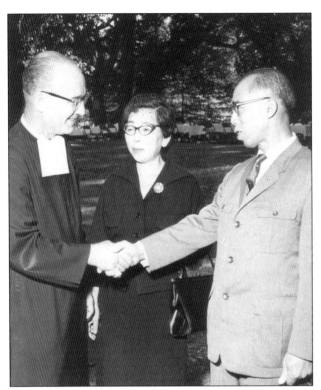

Pictured here are Mr. and Mrs. Ichiro Yano visiting the Christian Brothers during Africa Week in 1961. Mr. Yano was the director of Dai-Ichi Life Insurance Company of Tokyo and had been in the Napa Valley to meet members of Rotary International, of which he had recently been elected president. (Courtesy of Christian Brothers)

Pictured here in the 1890s is Mrs. Fortova-Hasek, reminding us how the winery folks have always tried to make the tourists from around the world at ease in the Wine Country. (Courtesy of Korbel)

The cool shade of the great trees in the wine country did the trick back in the 19th century, just as it does today. (Courtesy of Korbel)

It looks as though these ladies might have spent too much time in the tasting rooms! (Courtesy of Korbel)

When the weather just gets too hot for Napa Valley residents, the San Francisco Bay has always been a popular tourist destination, c.1890. (Courtesy of Korbel)

Located in the San Francisco Bay is world famous Alcatraz Island pictured here in the 1890s. Once a military supply garrison which became an Army prison and later a federal prison, today it is one of the many tourist-favored spots in the Bay Area. (Courtesy of Korbel)

But why leave the Napa Valley at all when downtown Napa has always had such a lovely waterfront district of its own, pictured here c. 1900. (Courtesy of Giancarlo Musso)

Index

Max Baer 111
Beaulieu Vineyards 8, 93, 94
Beringer Brothers
　8, 9, 10, 11, 12, 13, 15,
　107, 108
Cakebread 8, 91
Jake Cakebread 91
Cardinale 90
Caymus 8
Chandon 8
Chevalier Chateau 29
Chimney Rock 8, 98
Chimney Rock Golf Course 98
Christian Brothers 8, 72, 73,
　121, 124
Grover Cleveland 11
Clos Du Val 8, 96
Clos Pegase 8, 95
James Conant 105, 106
Copia 86
Francis Ford Coppola 25,
　26, 27, 28
Cosentino 8, 89
Mitch Cosentino 89
Culinary Institute of America
　23
Jack Dempsey 111
Domaine Carneros 8
Duckhorn 8
Peter Eckes 98
Buck Erickson 70
Eschol 60, 61
Etude 8
Far Niente 8
Henry Ford 4, 50
Katerina Fort 31
Freemark Abbey 8, 101
Future Farmers of America 39
Theodore Gier Winery 63–68
Gilded Age 24
Glassy Winged Sharp Shooter
　48

John Goelet 96
Charley Goldman 111
Michael Graves 95
Greystone 22, 70
Hakusan Sake Gardens 100
Frank Hasek 29, 30, 31,
　32, 35
Karla Hasek 30
Heitz Wine Cellars 8, 87
Hess Collection 8, 79, 80, 83
Donald Hess, 79
Inglenook 8, 24
Korbel 29, 36, 37, 38
Kort of California 112, 120
Charles Krug 8, 21
Bill Lane 122
Charles Laughton 103
La Famiglia di Robert Mondavi
　86
George de Latour 94
Carole Lombard 103, 104
Rocky Marciano 111
Markham Vineyards 8
Louis M. Martini 8, 99
Louis P. Martini 99
Michael Martini 99
Carolyn Martini 99
Mayacamas 8
Merchant Association of Napa
　County 69, 70
Anker Miller 70, 71
Cesare Mondavi 21, 22, 82
Peter Mondavi 22
Robert M. Mondavi 8, 22, 81,
　82, 83, 84, 86, 97
Mt. La Salle Winery 73, 74,
　77, 78
Mt. Tivy 73, 74, 76
Mt. Veeder Winery 97
Napa Cellars 88
Gusatve Niebaum 24
Niebaum-Coppola Estate 8

Opus One Winery 84, 85
Peju Province 92
Tony Peju 92
Phylloxera 51
John Portet 96
Prohibition 8, 38, 41, 59,
　60, 73
Raymond Vineyards 8
Franklin Delano Roosevelt
　59, 77, 105
Baron Phillipe de Rothchild 84
Ed Rossi 122
Saint Mary's College 121
V. Sattui Winery 8
Schramsburg Vineyards 28
Sharp Brothers 111
Jan Shrem 95
David Spalding 95
Jim Spalding 95
Stanford University 34
Sterling Vineyards 98
Stonegate Winery 95
St. Supery 8, 91
Sutter Home 16, 17, 18, 19, 20
John Sutter 18
Stag's Leap Wine Cellars 8, 97
Patsy Strickland 30
Trinchero Family 17, 18,
　19, 20
Mario Trinchero 17
Mary Trinchero 17
Roger Trinchero 19
John Thomann 16
Univeristy of California, Davis,
　Division of Viticulture
　39–58
Sheldon Wilson 98
Woodrow Wilson 59
Wine Train 101
Warren Winiarski 97